How
Prints
Look

Revised and Expanded Edition

How
Prints
Look

*Photographs
with
Commentary*

William M.
Ivins, Jr.

Revised by Marjorie B. Cohn

BEACON PRESS · BOSTON

WILLIAM M. IVINS, JR., was the curator
of prints at the Metropolitan Museum of
Art in New York from 1916 until his
retirement in 1946. He was the author of
many articles and several books, includ-
ing *Art and Geometry, Prints and Visual
Communication,* and *Notes on Prints.*
MARJORIE B. COHN is head conservator
and Philip and Lynn Straus Conservator
of Works of Art on Paper at the Har-
vard University Art Museums and
senior lecturer, fine arts, at Harvard
University. She is the author of *Wash
and Gouache: A Study of the Development
of the Materials of Watercolor,* and *Francis
Calley Gray and Art Collecting for
America.*

Beacon Press
25 Beacon Street
Boston, Massachusetts 02108

Beacon Press books are published under
the auspices of the Unitarian Univer-
salist Association of Congregations in
North America.

06 05 04 11 10 9 8

LIBRARY OF CONGRESS CATALOGING-IN-
PUBLICATION DATA
Ivins, William Mills, 1881–1961.
 How prints look.

 Bibliography; p.
 1. Prints. I. Cohn, Marjorie B.
II. Title.
NE863.I9 1987 760 86-47865
ISBN 0-8070-6646-X
ISBN 0-8070-6647-8 (pbk.)

Text design by Christine Leonard
Raquepaw

Contents

Remember that there are parts of what it most concerns you to know which I cannot describe to you; you must come with me and see for yourselves. The vision is for him who will see it.

Plotinus

Preface to the Revised Edition

The first edition of this text was published by the Metropolitan Museum of Art, in New York, in 1943. In 1958 it was reissued, with new reproductions for eleven of the illustrations, by Beacon Press. William M. Ivins, Jr., prefaced the reissue with the following note: "In the first edition the writer expressed his thanks to the late Alice Newlin and to Jean Leonard, Roberta Fansler (now Mrs. John Alford), and A. Hyatt Mayor for their most valuable criticism of the text. The excellent photographs on pages 4, 7, 8, 9, 10, 11, 16, 24, 25, 36, 74, 101, 102, 134, and 135 of this reprint were made by the photographers of the Metropolitan Museum of Art. The others were made by the writer from his 35-millimeter negatives."

In my revision of the 1958 reissue, I have been kindly assisted by Alan Fern, Henri Zerner, and

Daniel Bell. Supplementary photographs on pages 4, 43, 52, 95, 114, 115, 116, 117, 118, and 150 have been made by Elizabeth Gombosi and Rick Stafford of the Photoservices Department, Harvard University Art Museums.

I should like to note that while the text has been augmented by descriptions of additional print processes, with illustrations of twentieth-century examples, no attempt has been made to alter its perspective on traditional print processes, nor has the terse personal idiom of William M. Ivins, Jr., been expanded or homogenized. Certainly, his biases were formed in response to the reproductive print tradition, which was very much alive in his youth one hundred years ago and which is almost entirely forgotten in the late twentieth century. Yet his crotchets are as nothing to his perceptions, and every attempt has been made to respect his conviction that pictures, and looking hard, are more essential to an understanding of prints than words.

<div align="center">Marjorie B. Cohn</div>

Introductory Notes

This book is an elementary introduction to the appearances (the outward and visible signs) of prints. It is not a history, and it contains no technical recipes or instructions for print making. Most of the time spent over it should be given to looking at its pictures.

The legends under the illustrations are integral parts of the text. The names of the artists and of the prints reproduced are given in the List of Illustrations.

The illustrations nearly all reproduce details of prints. With few exceptions they have been enlarged, some of them very considerably. This has been done because the specific qualities of line and surface produced by the various graphic processes frequently lie below the threshold of unpracticed vision. No notation has been made of the scales of magnification, which vary ac-

cording to the characteristics which it was desired to illustrate.

Just as on the street it is often impossible to recognize a still figure a long way off but easy to do so the moment it begins to move, so with practice in looking it will be discovered that the lines produced by each graphic process have a characteristic gait or motion of progress that is frequently recognizable even when the lines are too small to be seen clearly or singly. On occasion, however, the diagnosis of process becomes exceedingly difficult, and no one can be expected to make no mistakes. In spite of much care that has been taken there are undoubtedly such mistakes in this book.

First Principles

If a drawing is made with a greasy pigment (e.g., printer's ink, oil paint, lipstick, etc.) upon a smooth nonabsorbent surface and a piece of soft paper is then pressed down upon it the pigment will leave the smooth surface and adhere to the paper. The pressure can be applied in various ways, as by rubbing the back of the paper, or, if the surface be a sheet of metal, by running the surface and the paper through a clothes wringer or an etching press. Prints made in this way are called monotypes because only one good impression of each can be made.

The difficulty of remaking or replicating the same greasy drawing upon the smooth surface, once an impression has been taken from it, is so great that for practical purposes it is impossible unless the surface has been treated in some way so that this renewal can

be done mechanically and not by redrawing. These methods of treatment of the printing surfaces and the ways of printing from them are called the graphic processes or techniques. In the beginning of their use the graphic techniques were comparatively simple. As time has gone by they have greatly increased in number and in technical complexity. It must be remembered that command over technical complexity, while requiring patience and skill, has little or no relation to creative artistry. One of the main reasons that so many artistically successful woodcuts, etchings, and lithographs have been made is the basic simplicity of those processes.

There are three great general groups or families of processes for treating a surface so that greasy ink may be mechanically deposited upon it in a predetermined and unvarying pattern. These families are known respectively as the relief, intaglio, and planographic processes. Each requires its own special kinds of tools, presses, inks, and incidental methods and materials, though many of these can be used interchangeably in producing either relief or intaglio printing surfaces.

In the following pages no attempt is made to do more than to describe the general principles underlying the great historic processes. For more detailed information, recipes, instructions, special tools, materials, and historical discussion, reference may be had to any number of technical treatises, of which a few are listed in the Bibliography.

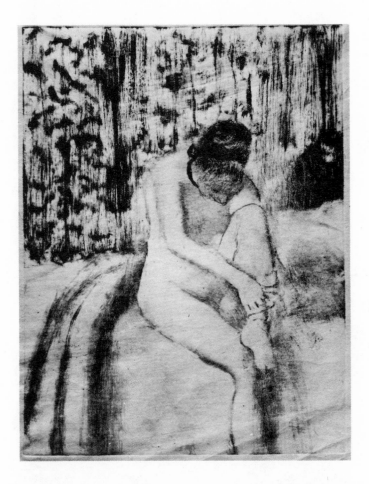

There are two kinds of monotypes, light field and dark field. In the light-field manner, of which this is an example, paint or ink is applied onto the clean plate to form the contour and shading of the design with little subsequent reworking. This monotype is slightly reduced in the reproduction.

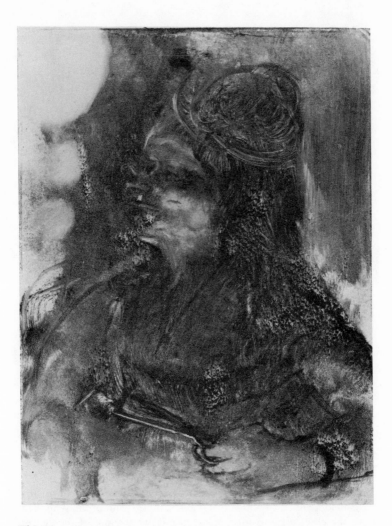

This is an example of a dark-field monotype, in which a layer of ink applied to the plate was extensively reworked and wiped away with rags, brushes, and the artist's fingers to form highlights and modeling. The original has been greatly reduced in the reproduction.

The Relief Processes

WOODCUTS

The oldest of the relief processes is the woodcut. It was used for printing textiles more than a thousand years ago, and in Europe it began to be used for the printing of pictures sometime about A.D. 1400.

The woodcutter, with small knives and gouges, cuts away the wood from between the lines that he or a draftsman has drawn on the smooth surface of a piece of wood. When carefully done the process can produce a fairly good reproduction of a pen line. Each side of the line has to be cut separately. Thus where the etcher or engraver thinks of a line as the trace of a single gesture, the woodcutter has to think of each single line as the result of several separate gestures.

The kinds of knives and gouges used depend upon per-

sonal preference and to some extent upon the fineness of the work to be done. Excellent work has been done with ordinary pen knives and scalpels. The illustrations on pages 7 and 8 show the knives used by the French woodcutter Papillon in the eighteenth century. The finer the grain of the wood and the higher the polish it will take, the finer the work that can be done on it. Apple, pear, box, and even maple are used. Woodcuts are usually made on the sides of the blocks cut plankwise from the tree ("side wood" or "side grain"), though they are sometimes made on blocks that are cut in cross section from the tree ("end wood" or "end grain ").

A block can be printed by rubbing the back of a piece of paper laid face down on the block's inked surface. Many of the early fifteenth-century woodcuts were printed by rubbing, as were some of the "block books," i.e., books the texts and pictures of which were cut on wood blocks. The paper on the back of a rubbed woodcut is usually shiny where the high points of the block have been pressed against the front.

Since the second half of the fifteenth century woodcuts have customarily been printed in ordinary type printing presses, and—for convenience in printing with and at the same time as type—the block's thickness is usually the height of the type ("type high"). Until the introduction of very smooth papers in quite modern times, the paper was always printed upon in a moist condition. Prior to the nineteenth century both type and blocks were inked by pounding them with stuffed leather "balls" on which the ink had been evenly spread. This method of inking put ink on the sides of the upstanding lines of the wood block as well as on their tops. Between 1810 and 1820 ink rollers came into use—at first in England.

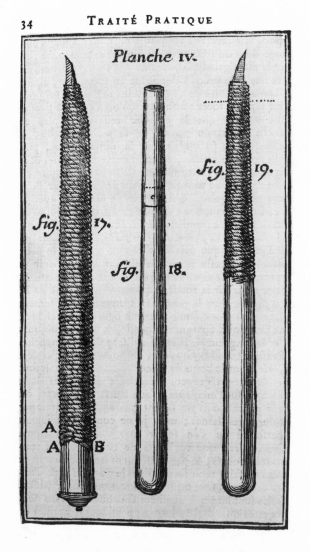

Planche IV.

fig. 17.

fig. 18.

fig. 19.

A
A B

Eighteenth-century woodcutter's knives, showing how the blade is
inserted in a cleft handle, which is then bound with cord to hold the
blade tight.

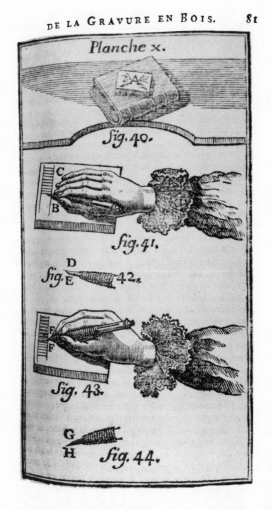

The method of cutting a wood block as practiced in the eighteenth century. At the top a small block, with the design pasted or drawn directly onto it, is laid on a book so that it may be the more easily turned while being cut. In the middle the woodcutter makes a cut along the side of each of a series of parallel lines. At the bottom he makes the second cut needed to disengage the sliver of wood along the side of the line.

This is a reproduction, slightly reduced, of a portion of an original
sixteenth-century Flemish wood block, on which the artist had made
his pen drawing and on which the cutter had begun his work. The
cutting was never finished and the block was never printed.

This is a reproduction, slightly reduced, of a portion of a late fifteenth-century German wood block from which a great number of impressions has been printed. The tops of some of the lines were deliberately made lower in some places than in others, so as to increase or decrease the pressure of the press in particular places.

This is a reproduction, slightly reduced, of a portion of an impression presumably printed in the 1490s from the block reproduced on the opposite page.

Educant oculi tui fidelis anima fletur
us compassionis igne·considerans qua

This fifteenth-century Italian woodcut illustration was printed at the
same time, in the same ink, in the same press as the type. First used
in a book in 1467, but possibly made well before that time, it is one
of the earliest reproductions of a picture.

A very few early woodcuts were conceived in terms of knife work rather than in terms of pen drawing. This is Italian fifteenth-century work.

This is a detail from an impression of an early sixteenth-century Ger-
man wood block in which the woodcutter cut out the artist's lines
instead of the spaces between them, so that they appear in the print
as white lines on a black ground. This impression was printed from
a worm-eaten block. The wormholes printed white and someone drew
lines over them in pen and ink, as can be seen in the area of the monk's
eye.

This is a detail from an impression of a fifteenth-century Italian wood block the work upon which was carried out both in black lines on a white ground and in white lines on a black ground. In the solid blacks the hollows between the ribs of the "laid" paper show as light parallel streaks. A solid black is one of the most difficult things to print evenly on handmade paper (compare p. 22), although in this case the shading is so felicitous that one may wonder whether the effect was not deliberate.

Sometimes it is difficult to tell whether the lines in a print were
conceived of as black on a white ground or white on a black ground.
This is Dutch work of the seventeenth century.

On rare occasion the artist and the woodcutter made stylistic capital of the fact that, while for the etcher or engraver a line is the result of one gesture of the hand, in cutting a block each of the two edges of a line has to be separately disengaged from the wood. This is eighteenth-century English work.

German woodcut designers habitually used the regular calligraphic drawing of their national school (see pages 11, 19, and 20), and in a formalized way. The Italians drew and cut on their blocks much more freely and naturally (see pages 13, 15, and 22). Here a sixteenth-century Italian drew on the block as freely as though sketching on paper.

This is a slightly reduced reproduction of a fine impression of a sixteenth-century German woodcut in which the artist drew his lines very close together so as to produce an effect of tones. The cutter produced a very good "facsimile" of the artist's pen lines, an especially difficult and tedious task in the cross-hatched shaded areas.

A is a "proof" impression of an early sixteenth-century German woodcut with exceptionally fine and minute lines. It has always been considered one of the greatest technical triumphs of woodcutting. B is an impression from the same block as it was printed in a mid-nineteenth-century book. C is a copy engraved, not cut, on wood before the invention of photography. It was considered a very remarkable performance. D is an original "proof" impression of another subject from the same series. All are slightly reduced in the reproductions.

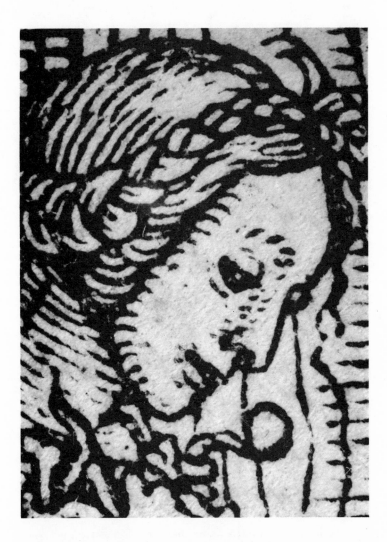

This is a greatly enlarged detail from *D* on the opposite page. Note the shading in the cheek, which is hardly visible in the natural size. The way in which the tops of the lines print paler than the bloblets of ink on the sides of the lines can be seen, and also how the ink clogged up the spaces between the fine lines (e.g., in the eye).

This is a detail from a finely drawn and cut Italian sixteenth-century wood block printed upon "laid" paper, the horizontal ribs of which were coarser than the lines of the block.

METAL CUTS

In the late 1400s men began to use relief printing surfaces of metal as well as of wood. On occasion it is difficult to tell at first glance whether a print was pulled from a metal or a wooden surface. There is no practical difference between the ways in which wood and metal relief surfaces receive and deposit ink. In making metal cuts the old engravers cut away from the surfaces of their metal plates the parts that were not to print, just as the woodcutters did with wood blocks, except that instead of using knives and gouges they used the punches and engraving tools used by silversmiths and goldsmiths for the decoration of their wares. The metal plates, after being engraved, were fastened on pieces of wood and then printed as though they were woodcuts. Some engraver's tools are reproduced on pages 49 and 50.

Until recently, when offset lithography has come to dominate commercial printing processes, so-called line and halftone cuts in modern periodicals, books, and newspapers were usually printed from etched relief metal plates made by photomechanical processes.

This detail from a late fifteenth-century German metal cut shows that the metal plate was mounted on a piece of wood. The head of one of the nails that held the plates on the wood can be seen in the border line above the halo. The difference between the engraved lines, which print white, and the punched dots is obvious.

This is a detail from an illustration in a prayer book printed on vellum
at Paris in 1498. In it the artist has largely imitated a black-line drawing,
in contrast to the white-line representation on the opposite page. The
original engraved relief plate of copper from which it was printed was
in a private collection in Paris and was used for printing as late as
1899. Compare the white flicks in the ground with the flicks in the
illustrations on pages 40 and 84.

In the 1790s William Blake, instead of engraving away the whites in his relief metal printing surfaces, etched them away. He claimed that the technique was revealed to him in a dream. It is now a standard part of photomechanical relief processes. Blake printed his etched relief plates in single colors, e.g., red or green, and afterwards painted them up with watercolors more or less elaborately as he received more or less money for them.

This is a detail from a French nineteenth-century newspaper cartoon in which some of the lines look as though they had possibly been executed in a variety of the "chalk plate" technique. In this process a layer of chalk, of the consistency of plaster, was spread over a flat metal plate. The artist then scratched his lines through the dried chalk down to the metal surface. The plate was then used as the mold for a casting in type metal. The type-metal cast was then printed like a woodcut. Sometimes white lines were engraved in the broader blacks of the casting.

WOOD ENGRAVING

In the second half of the eighteenth century Thomas Bewick, a plate engraver of Newcastle upon Tyne, discovered that if he used a piece of end wood (see page 6) he could engrave upon it just as the makers of metal cuts and copper engravings had engraved upon their metal plates, provided he held his tool in a slightly different way (see pages 29 and 50). Except in "facsimile cuts" of pen drawings, the engraved lines in a wood engraving appear white on a black ground. Bewick and his pupils made many experiments in the new technique. Their discoveries soon became common practice in England and slowly spread to the continent of Europe and to America. By the middle of the nineteenth century the wood-engraving techniques were in universal use as the standard ways of illustrating books and magazines and remained as such until the end of the century, when photomechanical processes displaced them for all except some limited and usually self-conscious purposes.

The number of wood engravings reproduced here is perhaps larger than is necessary to show the bare process divorced from the drawing of the lines it was used to produce. By increasing the number it has been possible to show how the wood engravers' minds were so conditioned, as the psychologists say, by the other more familiar kinds of printed pictures, that they spent much of their time imitating other processes rather than in discovering the peculiar qualities and freedoms of their own. This is a trait common to all men using a new process. It is particularly noticeable in wood engraving, which is, except for lithography, the youngest of the classical graphic processes.

In the middle of the nineteenth century people began to print photographs upon blocks of end wood, which were then engraved. This eliminated the draftsman and was therefore regarded as a great step in advance. The process in general produced only rather poor handmade substitutes for the not yet invented "halftone," but two generations of people grew up who knew the great paintings only through these prints. Their effect upon American aesthetic ideas was very great.

A nineteenth-century wood engraver's hands, showing how he held his block balanced on a pad and how he held his engraving tool as he pushed the block against it. Compare this technique to those illustrated on pages 8 and 50.

This is one of Bewick's own engravings on wood. Careful looking
will show that he thought in terms of his whites and not of his blacks.
The texture of his blocks was so fine that when really good impressions
were wanted it was necessary to print them on the ribless paper that
came from China in the tea boxes.

EMORY, wafted by thy gentle g

Bewick's pupil Luke Clennell showed that finer reproductions of pen drawings could be made by wood engraving than by woodcutting. When one of these prints is enlarged, however, as here, it betrays the fact that it was engraved and not cut, e.g., the lines in the hair are white and not black lines. This minuteness of workmanship determined the way of most of nineteenth-century book illustration and brought about the general use of very smooth papers in books.

William Harvey imitated the artificial linear systems of the reproductive engravers on copper. It took him several years to engrave this block. When it was finished there was no type-printing press strong enough to print it, although it was only 14¾ by 11⅜ inches in size. Some years later, when a strong enough press was found, the little pieces of wood of which the block was formed had shrunk apart, and the white lines left by the cracks had to be retouched by hand. Only a few proofs were pulled on China paper, the sole paper then available that was smooth enough.

By the 1840s wood engraving had become a technical trade carried
on in highly organized shops by many anonymous workers. Many
of the important artists of the time made line drawings on blocks to
be engraved in these shops. In spite of the routine nature of the en-
graving many of the "woodcuts" thus turned out were masterpieces
of design. In designing this woodcut Daumier introduced a caricature
of himself as the figure blowing the flageolet.

Comparatively few of the men who have engraved on wood have made their own designs. Among the great exceptions was William Blake, who, though a professional engraver on copper, must be regarded as an inspired amateur in his work on the wood, on which he sketched as freely with his engraving tool as he did with pencil on paper.

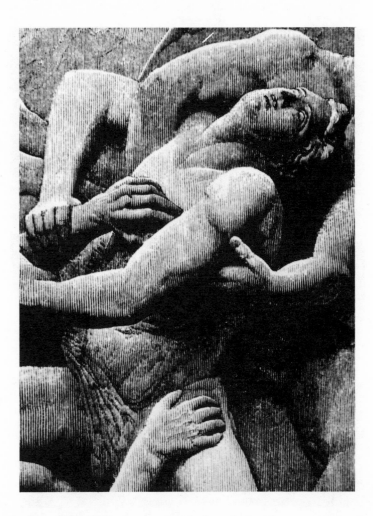

In the middle 1850s photography had reached such a state of development that it was possible to print photographs on wood blocks, which could then be engraved. This made for a much greater accuracy in reproduction of works of art in relief printing surfaces than had ever before been possible. Thomas Bolton, who engraved this, may have been the first to photograph his subject onto his block. Curiously, the lines in this print are "black" and not "white."

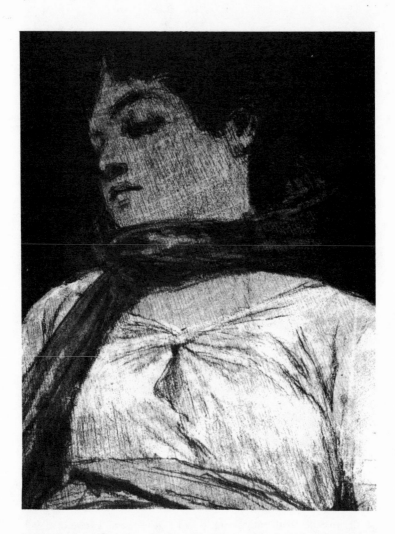

In spite of the fact that they could photograph their drawings onto the blocks, artists continued to draw directly on the blocks. Many of them, instead of making line drawings, made wash drawings on the blocks, which were then "interpreted" or "translated" by the engravers. This detail from a wash drawing on an uncut block by Mary Halleck Foote shows the rings of growth and the radial lines of the tree from which the end-wood block was cut.

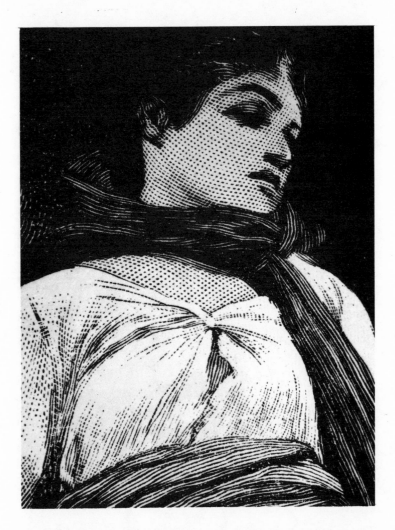

The engraver to whom the block reproduced on the opposite page was sent liked the drawing on it so much that he kept it and had it photographed on another block, which he engraved instead. This detail from a print from the block that was engraved shows how the engraver translated the artist's tones into lines and dots.

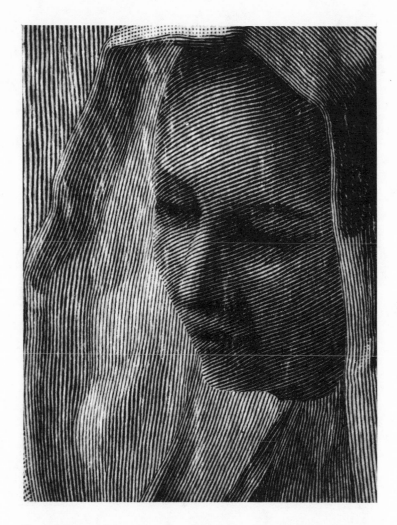

Out of the routine anonymity of the engraving shops in America a few men emerged as virtuosi of white-line engraving and achieved personal recognition as artists. One of the best known of these virtuoso engravers was Henry Wolf, who took pride in the accuracy with which he rendered the color values of the tones in painting. It is interesting to compare the linear scheme shown in this detail from Wolf's wood engraving after a painting in the Metropolitan Museum of Art with the seventeenth-century copper engraving reproduced on page 65.

This is a reproduction of a photograph of the detail of the painting reproduced in the engraving shown on the opposite page.

Another, perhaps the most famous, virtuoso engraver was Timothy Cole, whose prints after paintings by the old masters were very well known. Like those of Wolf, his originals were photographed onto his blocks before he engraved them.

This is a reproduction of the same detail shown on the opposite page, except that here an electrotype of the block was printed as though it were an etching. It shows that the wood engraving was a sort of adaptation of an eighteenth-century intaglio technique (see page 99) in reverse, in relief, and on wood instead of copper. The dots, however, being made with an engraving tool, have much the same shape as those in flicked engravings on copper (see page 84).

Of all the virtuoso wood engravers W. J. Linton was perhaps the most brilliant and expressive in his use of the engraving tool, as well as the freest and least subject to any established routine of linear system. His graphic style on wood is analogous to that of the nineteenth-century engraver on copper Gaillard (see page 68).

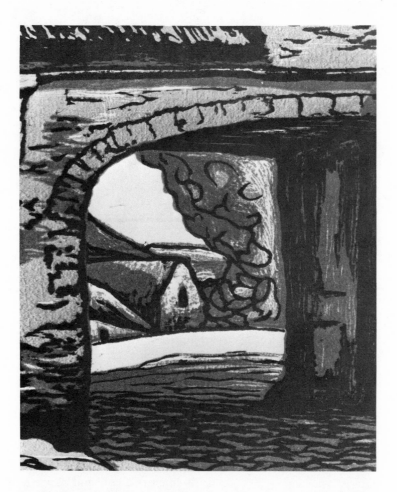

Besides the traditional wood and metal blocks and plates used for relief prints, modern printmakers have used linoleum blocks. The grainless, comparatively soft surface of linoleum permits great freedom in the cutting, with the tool moving easily in any direction, as can be seen in the loose scratches and crumbly edges of this enlarged detail. The reproduction is from a chiaroscuro (see page 119) "linocut" printed in three colors.

The Intaglio
Processes

Any slightest scratch or mark that
disturbs the surface of a highly
polished plate of metal will hold
printer's ink and can be printed.
Any method by which a design
composed of such printable
marks is made is called an intaglio
process. Each such dot or line, no
matter how small it is, has the
specific character that accompa-
nies the technical means by which
it was made. Thus, for example,
an etched line has the same char-
acter whether it be microscopi-
cally fine or so bold and coarse it
can be felt with the finger tip. It
is possible to make pits, scratches,
or incisions in the surface of a
metal plate that are so fine and
close together than prints from
them appear as unbroken tints to
the naked eye.

The three basic types of inta-
glio work upon metal (usually
copper) plates are drypoint,
engraving, and etching. All the

other intaglio methods belong to one or several of these basic types.

In *drypoint* the surface of the plate is torn by a sharp point thrust into the surface and dragged along it. The tool is held like a pencil. It is usually a small, pointed steel rod, though sometimes a diamond point is used. The metal displaced by the motion of the point is not detached from the plate but stands up above it in a burr (i.e., a rough ridge of sharp points) on one or both sides of the trench, or rut, ploughed in the surface by the moving point. The cross section of the rut is V-shaped. The amount of burr thrown up and its disposition depend upon how hard the point is pressed into the surface and the angle at which it enters it. The burr wears away very rapidly in the course of printing.

In *engraving* V-shaped trenches are cut into the surface of the plate by a tool called a graver, or burin, which is pushed along the surface. The graver is a steel bar with a lozenge or V-shaped cross section and a sharpened end, which acts like a scoop or gouge and cuts out a shaving from the metal surface along which it travels. It has a handle usually of wood, though frequently it is merely an old cork, which rests against the ball of the hand while the metal shaft is held in the fingers (see pages 49 and 50). No matter how sharp the graver is, it always leaves a minute burr along either side of the trench that it cuts in the metal surface. The early engravers let this burr wear away in the course of printing of the plate. Later engravers scraped the burr away before they began to print their plates.

Etching is a process by which lines are chemically eroded in the surface of a metal plate. The polished plate is covered with a specially prepared "ground," the principal component of which is wax. The grounded plate is then blackened with smoke. The artist draws his design on the blackened ground with a point, or "etching needle." The size, shape, and weight of the tool are matters of personal convenience. Many etchers use sewing needles mounted in the ends of sticks of wood, others small sharpened bars of steel. Félicien Rops is said to have etched with a toothpick, and J. M. W. Turner with a fork that had lost all but one of its tines. In theory the etcher presses just hard enough on his point to scratch through the ground but not to dig into the plate.

The drawn lines appear as bright metal against the blackened ground. Acid (frequently dilute nitric) is then applied to the grounded surface. It "bites," or dissolves away, the bright metal exposed in the lines, but does not go through the ground. The breadth of the lines depends to some extent upon the length of time the lines are exposed to the acid. The depth of the lines depends entirely upon how long they are exposed to the acid. If the artist wishes different lines on the plate to be bitten out at varying depths, he will "stop out" the lines he wishes to be the shallowest; that is, when a group of lines has been bitten enough, the acid is removed from the plate and a brush loaded with ground dissolved in a solvent is passed over them. The plate can then be returned to the acid for further biting of the lines not so "stopped out."

The three basic intaglio processes are frequently used in conjunction. An etched plate can be touched up or finished in either or both engraving and drypoint. Very fine engraving can be touched up in drypoint and the burr then removed from the drypoint touches. It is very difficult to distinguish between light engraved lines and drypoint lines from which the burr has been removed.

The vocabulary of the collectors and dealers is frequently very misleading and at variance with the actual technical facts. Many "etchings" contain much drypoint or engraving, and many "engravings" are almost entirely etching. Seymour Haden, a British etcher, insisted that Charles Meryon was not an etcher ("eau-fortiste") but a painter engraver ("peintre graveur") because he made so much use of the engraving tool in finishing his plates. According to the historical usages of technical terms, the method by which the lines in a print are laid has nothing to do with its classification as an etching or an engraving. Traditionally every intaglio print in which the lines are laid in a formal manner is an "engraving," and every one in which they are laid freely is an "etching." (Compare remarks on page 159.) Abraham Bosse, who in the seventeenth century wrote the first treatise on etching, used special etching needles that enabled him to make etched lines that looked like engraved lines. For reproductions of his work see pages 49, 50, and 51.

The *method of printing intaglio plates* is basically the same no matter what particular processes have been used on them. Stiff

tacky ink is spread over a warmed plate and worked down into its lines. The plate is then wiped with rags and finally with the palm of the hand to remove the ink from the metal surface but not from the lines or scratches in it. This done, the inked plate is laid face up upon the bed, or plank, of a roller (or etching) press. Damp paper is laid on the plate and over the paper are placed felts or pieces of blanket. The handles of the press are then pulled and the bed with its burden is run between two heavy rollers (see page 51). The pressure of the rollers on the blankets crushes the damp soft paper into the lines in the plate so that it takes up the ink from them.

Engravings are usually wiped "dry" so that no ink is left on the surface of the plate, but many etchers deliberately leave films of ink on the surface of their plates. Rembrandt and, especially, Whistler made much use of this trick. The drier the plate the more brilliant is the contrast between the white of the paper and the black of the ink. Also, the consistency and color of the ink greatly affect the potential for clean wiping and brilliant effects.

A heavy-handed printer can wear out a plate very quickly, especially if it contains any drypoint. The burr on a drypoint or engraving catches and holds drifts of ink on its side just as a furrow holds drifts of snow on the side away from the rut. The strength and lasting power of the burr depend very largely upon the hardness of the copper plate. Modern rolled plates are not so hard as the old ones that were planished with a hammer on an anvil until they rang. As the burr wears away it holds less and less ink along its side. Thus what in an early impression may be a broad, juicy, blurry line, in a late impression may be a very hard, thin, dry one. If drypoint and etching have been combined on a plate, the drypoint burr will wear more quickly than the etched lines and the original balance of the effect will be greatly altered.

A copper plate can be "steel-faced" by electroplating it with a microscopically thin film of pure iron, by a process invented in the mid-nineteenth century. Steel-faced plates wear much longer, especially when they have any drypoint work on them. Given equal care in printing, no one can tell the difference between impressions from the bare copper and the steel facing. Some of Whistler's most famous plates were first published

from plates that had been steel-faced. Haden made it a regular practice to steel-face his plates and thanks to it he was able to print successive editions from many of them over periods as long as thirty years.

The limitation of the number of prints from a plate to a small number such as thirty or forty is not, therefore, necessarily predicated upon wear of the plate but upon the immediate commercial advantages of a quick and artificial rarity.

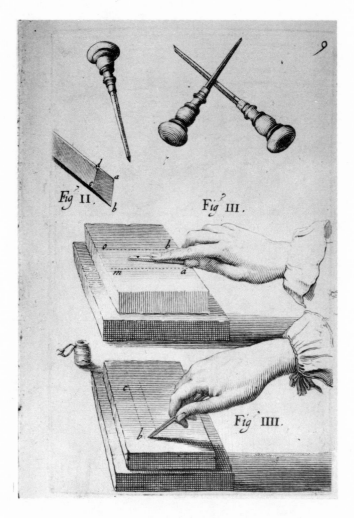

Seventeenth-century burins, or gravers, showing the whole tool, the cutting point (II), and the method of sharpening it (III, IIII).

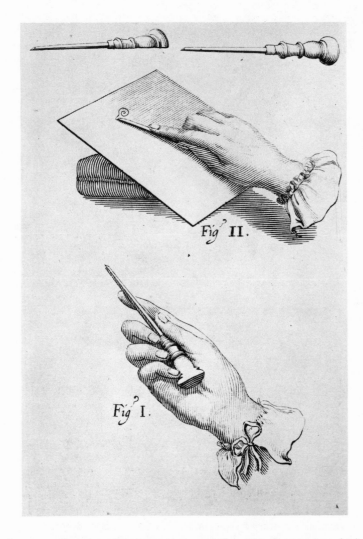

Seventeenth-century burins, or gravers, showing the way in which they were held (I) and used on copper plates (II). The plates were balanced on little pads so that they could the more easily be turned for convenience in working. The plate was pushed against the tool just as much as the tool was pushed against the plate. Compare to the wood engraving technique shown on page 29.

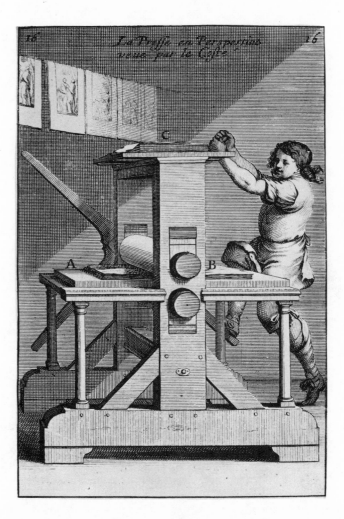

La Presse en Perspective
veue par le Costé

A seventeenth-century etching or engraving press, showing how the bed of the press (*A*), on which were laid the inked plate, the dampened paper, and a pile of felts or blankets (*B*), was pulled by two rollers, which were turned against each other by rotating the large handles. Fresh impressions were hung up to dry (*C*).

When a drypoint plate is inked and wiped, ink is left alongside the burr on the lines just as a drift of snow is left by the wind along a furrow. This produces warm, furry lines that are alike in no two impressions. The earlier the impression is the higher and stronger the burr was on the plate at the time it was printed and the blurrier and softer the lines are apt to be on the print. In this enlarged detail the shaded, slightly translucent tones of drypoint contrast with the un-modulated black of etched lines.

In very heavy drypoint the tops of the burr stick up through the ink on either side of it and sometimes in printing produce thin white lines like scratches in the heavy blacks.

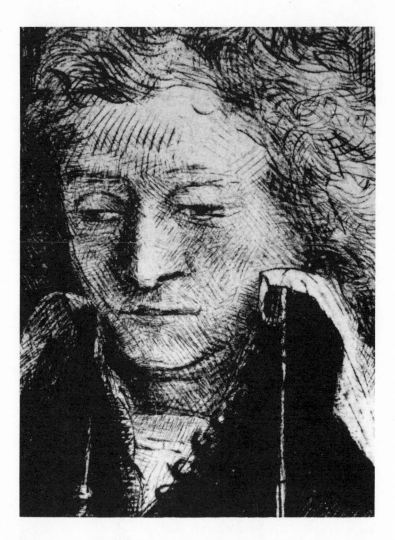

The burr on drypoint lines, when not too heavy, can easily be burnished down by rubbing with a piece of polished steel or an agate. Here it can be seen how the artist changed his work on the plate (e.g., in the left eye) just as though he had been working with a pencil and an eraser on paper.

This greatly enlarged detail from a very early impression of a late fifteenth-century German engraving shows how the printmaker strengthened several of a group of engraved lines by digging into them with a drypoint. The burr and the ink lying along it are clearly visible, as is the typical sharply tapered, clear stroke left by the engraving tool in the unstrengthened lines at the left.

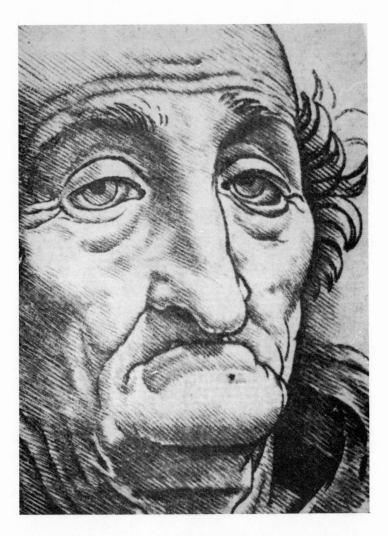

Early impressions of many fifteenth-century Italian engravings have a peculiarly soft, uneven quality of line quite unlike that with which we are familiar in German prints.

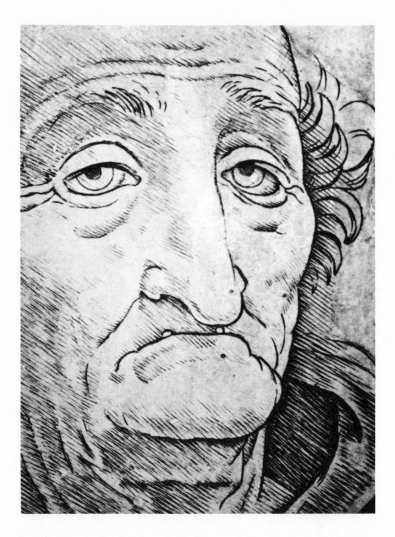

Late impressions of such early Italian engravings have a hard, bare, stringy quality of line. Compare this late impression with the early one from the same plate on the opposite page. The harsh effect of wear is exaggerated by the abandonment by later Italian printers of the thin, less viscous ink used in Italy in the fifteenth century and their adoption of the thick, glossy black ink popularized by German prints, which were widely imported into Italy in the early sixteenth century.

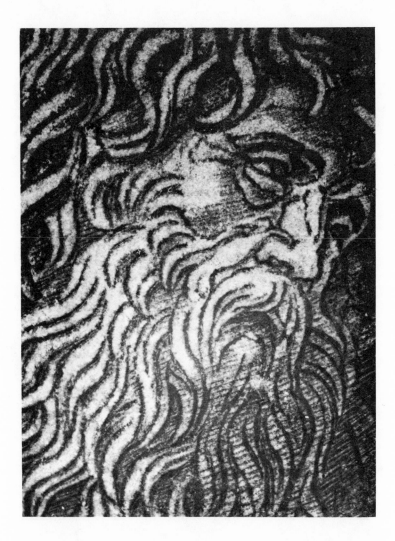

In some very unusual early impressions of fifteenth-century Italian engravings the strong white lines of the top of the burr can be seen, indicating that the edges of the engraved lines were not burnished before the plate was printed.

This is a great magnification of several of the lines reproduced on the opposite page. The way the ink lies in the lee of the burr, that is, the raised lip of the unburnished engraved lines, is plainly visible.

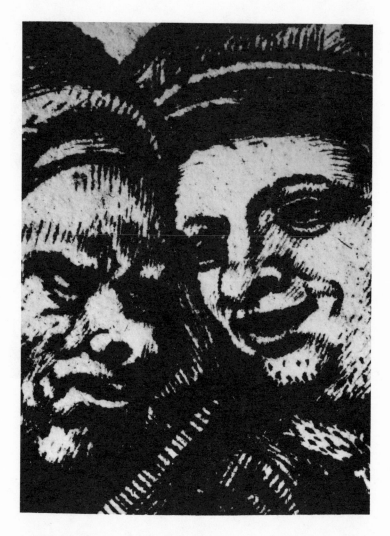

As the earlier engravers did not habitually scrape the burr from their lines the very early impressions from their plates are apt to have a peculiar warmth and fullness of line. This is a detail from a very rich early impression of a fifteenth-century German engraving.

On occasion there occur very pale impressions, almost without ink in their lines, but printed from plates in perfect condition. These are sometimes of great, though ghostly, beauty. They were presumably printed as a means of cleaning the plate after a day's printing and are called "maculatures." Nowadays plates are cleaned with benzine or gasoline.

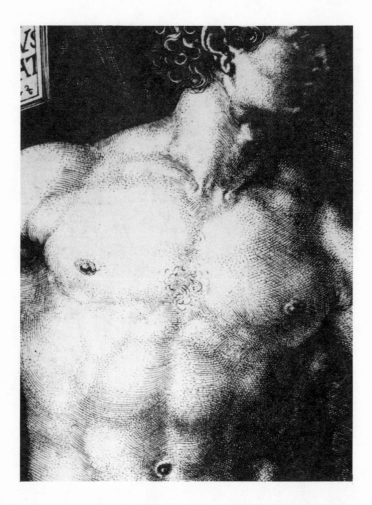

The principal technical difference between early German and early Italian engraving is not so much in the printing quality of the lines as in the way they were drawn (or laid). The methods of laying lines on engraved plates corresponded closely with the methods of laying lines with pen and ink in use in each country. This detail is from an early sixteenth-century German print.

The German and Italian schools naturally influenced each other. Marcantonio, a sixteenth-century Italian, in his later work produced a sort of synthesis of the linear schemes of the German woodcutters and the Italian copper engravers and started engraving on its way toward having its own specific methods of laying lines. The German print on the opposite page is a portrait of a surface, with all its little stresses and tautnesses. This Italian print is a schematic indication of the volumes that lie under a surface.

In the middle of the sixteenth century Dutch engravers began to make
stylistic play with the capacity of the engraved line to start thin and
sharp, swell to a certain thickness, and then taper away again.

In the seventeenth century in France a certain kind of lean stylization was carried very far. In the nineteenth century this was revived in some American white-line reproductive wood engraving (compare page 38).

Later the French developed a plumper but most methodical and artificial manner of laying lines, especially in "reproductive engravings" after paintings, drawings, sculpture, etc. To bring out its full brilliance it was necessary that the burr should be removed from the engraved lines before printing began.

Out of the precedents typified by the engraving on the preceding page there gradually evolved the "lozenge and dot" linear system familiar in "bank-note" engraving. This was possibly the most highly artificial convention ever adopted in the graphic arts. It had its origin in the economics of the business of making reproductive engravings (see page 160) but was long accepted by the public as the typical method of engraving.

How artificial the linear structure exemplified in the preceding illustration was, and how little needed for representation, is shown by this detail from a famous engraving by a mid-nineteenth-century French engraver, which is often pointed to as one of the great technical triumphs of engraving.

This is a detail from a modern impression taken from a plate from a twelfth-century chandelier that was decorated with engraved lines several hundred years before men learned how to print from engraved plates. Its artistic merit is as much greater than that of the prints reproduced in the preceding four or five illustrations as its technique is simpler and more rudimentary than theirs. It does not, however, begin to convey nearly as much information as they do about form and texture. The holes for the rivets that held the metal plate in place in the chandelier can be seen.

The details on this and on the opposite page illustrate the difference between typical engraved and etched lines. They are from two prints of the same size after the same painting. This is an engraving, the other is an etching. Both are seventeenth-century work.

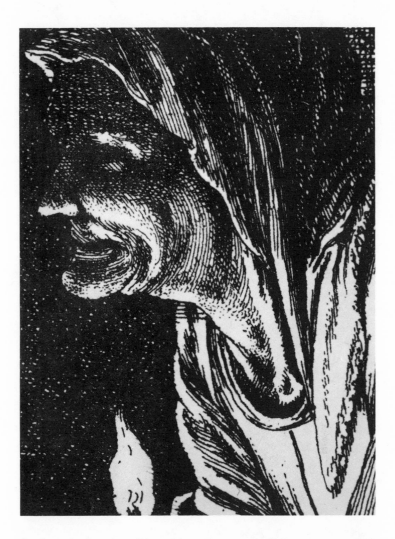

As the etcher's point glides with perfect ease in all directions over the grounded plate, the lines made by it have a nervous, muscular tremor lacking in lines made by such tools as the drypoint and graver, which are pushed down into the metal and held stiffly by it. This slight tremor is perhaps the most easily recognizable characteristic of the etched line.

This greatly enlarged reproduction of a tiny figure from a dry-wiped impression of a seventeenth-century French etching on copper shows very clearly that etching is a process of erosion. The sides of the etched lines have the same character as the crumbling sides of a small rivulet in dry soil. The ends of the lines are blunt and not sharp as are the ends of engraved lines. Compare the quality of these lines with that of the engraved and drypoint lines reproduced on page 55.

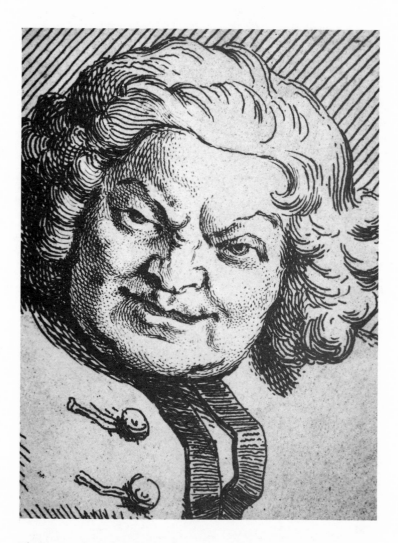

The ease and quickness with which etching could be done made it a favorite medium not only for rapid sketches but for pictures with "news value." At a time when Lord Lovat, the last man to be beheaded in England, was much in the public eye, an artist made this rapid etched sketch of him and made a lot of money by selling prints at a shilling apiece.

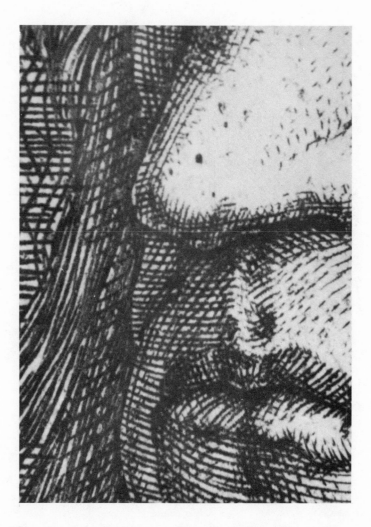

The earliest etching plates were of iron. The earliest etchings on copper were made about 1520. In this print of that year both etching and engraving were used. As it was not practical to engrave on iron, this plate must have been made of copper. With a little careful examination the two kinds of lines can be differentiated, e.g., the coarse shading lines in the upper lip have blunt ends and are therefore etched, but the shading dots taper to fine points and were done with an engraver's burin.

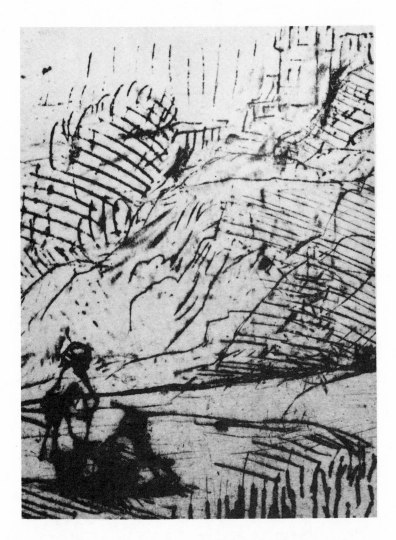

A seventeenth-century Dutch artist, displeased with a passage in one of his etchings, cut the surface of his plate away in that part, gave it a hasty burnishing, and reworked it in drypoint. The smooches were made by the ink held in the roughnesses that were left by the knife as it cut the surface away and that, through haste, were not burnished.

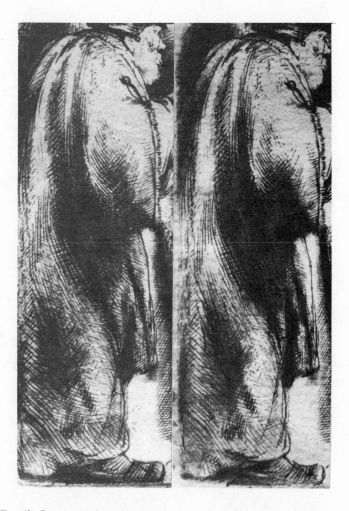

Details from two fine impressions of the same plate, which was first etched and then shaded and pointed up with engraving and drypoint. The left is the earlier impression. The right shows not only wear and the breakdown of lines but the introduction of new engraved lines to "pick up" the plate.

Etching has been used at various times to produce reproductions of paintings, drawings, etc. In these reproductive prints the etched line was frequently as artificial and stylized as that in any engraving. Prints like this are called "engravings" but in fact they contain less engraving than many "etchings."

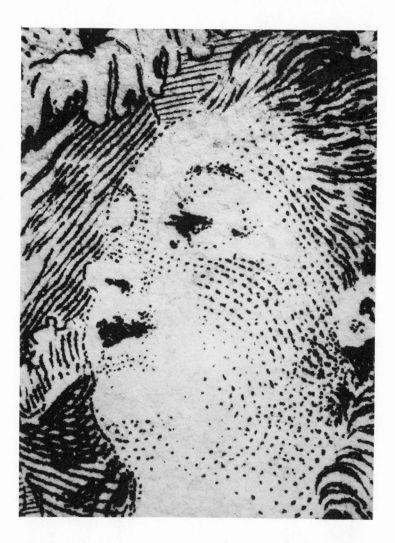

Time was money in the routine engraving business as in some others. To speed up the work on a plate it was often carried as far as might be in etching and drypoint and finished in engraving. This explains why the first states of so many eighteenth-century engravings are referred to as the "etched states."

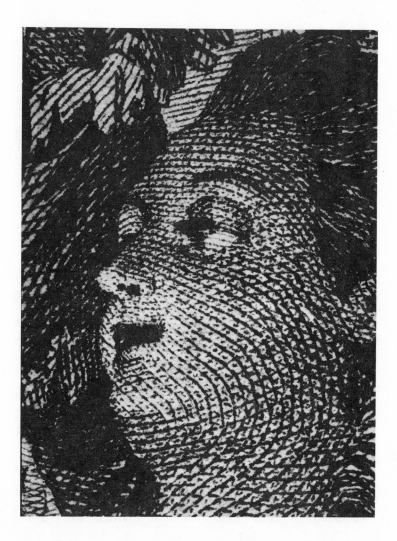

The reproduction on the opposite page shows the "etched state" (which includes much drypoint), and that on this page shows the finished state, of the same detail in a French eighteenth-century "engraving." The etching in work of this kind had naturally to be done in highly formalized lines of the same general character as the stylized engraved lines used in finishing.

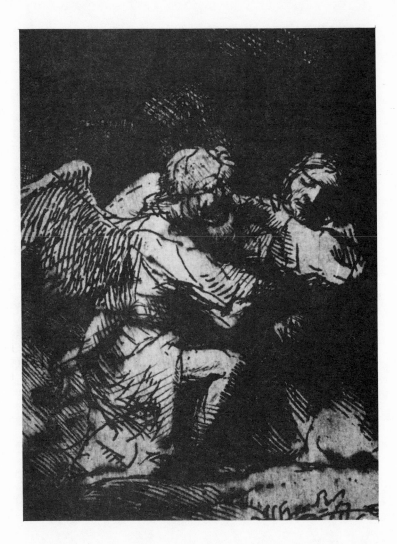

Drypoint was frequently used with etching to gain added color and dramatic effect, as in this seventeenth-century Dutch print. The drag of the ink left on the surface of the plate in wiping it can be easily seen.

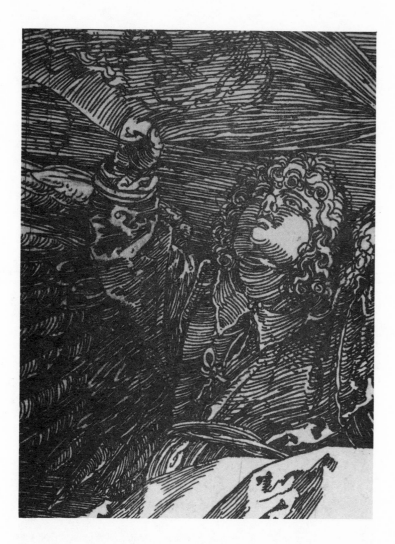

The heightening of the color and contrast obtainable by intentional manipulation of the ink during the process of wiping the plate began very early. This is a detail from a German etching on iron made in 1516, which was bitten so evenly all over that clean, evenly wiped impressions from it lacked contrast and sparkle and had a flat appearance. The finest early impressions from the plate were therefore deliberately wiped so as to leave more ink in the lines and on the surface of the plate in some places than in others.

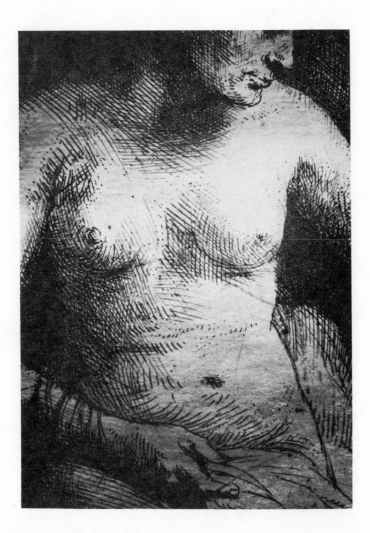

This is a somewhat enlarged and greatly intensified reproduction specially made to emphasize the way in which a seventeenth-century Dutch artist left films of ink on certain parts of his plate. Although they are so slight as to be hardly visible in the original, they were very deliberately and carefully made and their artistic effect is very great.

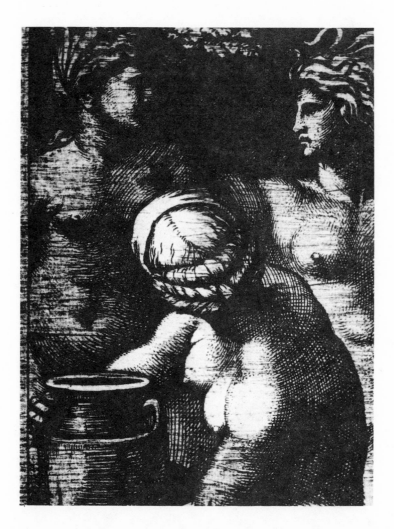

Shortly after 1500 some engravers found it desirable to make exactly repeatable smooches, tints, or tone shading. This detail from an early sixteenth-century Italian engraving shows one of the earliest attempts to solve the technical problem of producing tones that were definitely controlled through work on the plate. Here the engraver roughened the surface of his plate by rubbing it over with a fine abrasive, then burnished the parts he wanted to be brilliant, and finally engraved the lines on the plate.

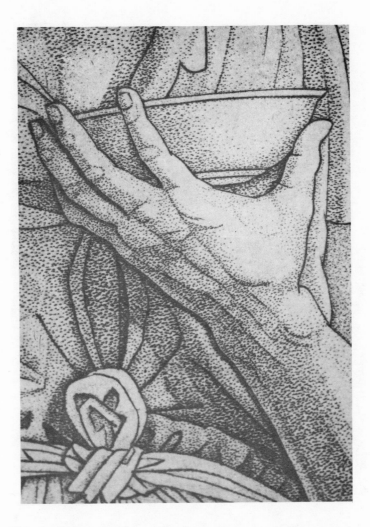

This detail from another early sixteenth-century Italian engraving shows still another early method of producing tones, more laborious than that exemplified in the preceding illustration, but having the advantage that by its use soft lines as well as flat tones could be produced. This method consisted in dotting or flicking the copper with the point of the graver.

In the earliest years of etching men made experiments toward ways of producing more definitely controlled tones than was possible by mere skill in wiping their plates, and even of producing soft lines. It seems not to be definitely known how this early sixteenth-century German print was made, but it may well have been done in somewhat the manner exemplified in the next illustration.

In the seventeenth century Dutch etchers occasionally produced the minute dots or pits in the surfaces of their plates that were needed for a controlled tone effect by painting the plate with a mixture of oil and powdered sulphur, or some other chemical, which pitted the plate in a delicate tint. In this portrait important parts of the modeling are carried out in such a sulphur tint. Careful looking will discern burnisher marks and supplemental drypoint in the right eye and just under it, as well as in other places.

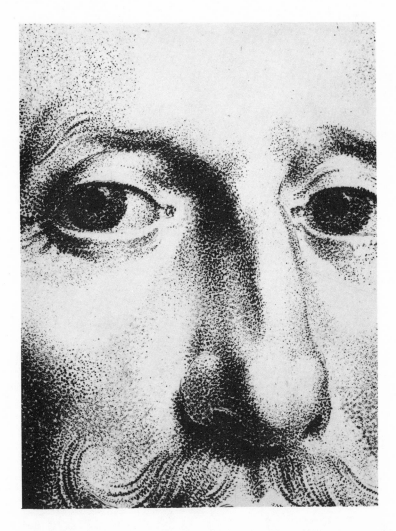

In the 1600s men began to experiment toward producing controlled tones on copper plates without the use of etching or the engraving tool. In this portrait practically all the work was done by hammering or tapping sharp points into the copper.

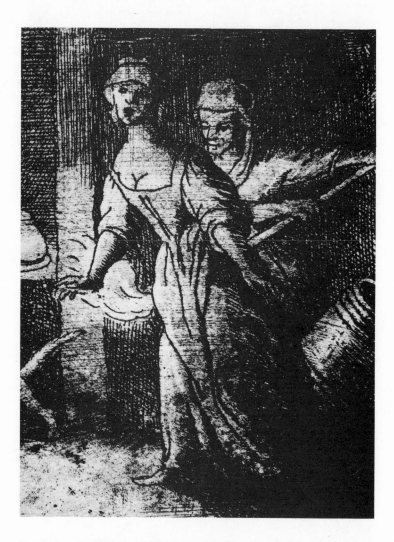

Some seventeenth-century Dutch experiments in tone look almost as though their effect had been achieved by rolling rattail files over etched plates.

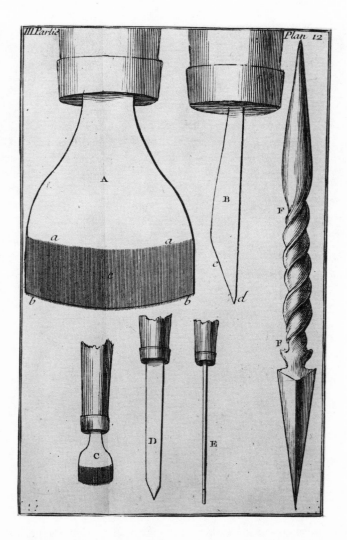

An eighteenth-century illustration of two mezzotint rockers, one big (*A*, front view; *B*, side view), for laying the original ground, and one small (*C*), for retouching, together with a combination tool (*F*) having a three-cornered knife at one end and a burnisher at the other, with which to cut away and burnish down the mezzotint ground or burr. The shaded lines (*a, b,* in *A*) represent lines deeply engraved on the surface (*c* in *B*). When the tool is ground to a bevel (*d* in *B*) these lines make very fine teeth along the curved bottom of the tool. The rocker is held upright and pushed while being rocked back and forth with its rounded edge pressing on the plate.

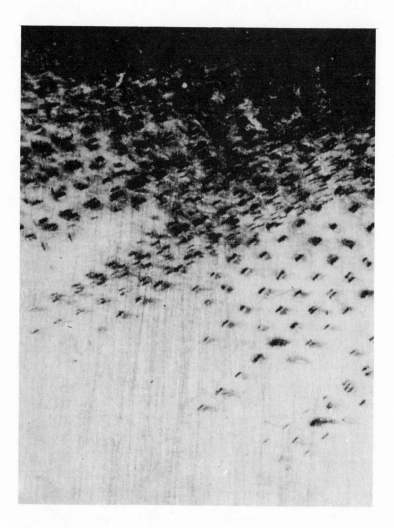

The invention of the rocker (see the reproduction on the preceding page) later in the eighteenth century made it possible to lay an even, close burr all over the surface of the plate. The tints were then scraped or burnished into the even tone of the burr. Engravings printed from rocked surfaces that have been scraped and burnished down are known as mezzotints. This enlarged reproduction of an impression of the uncleaned margin of a mezzotint plate shows the effect of the rocker.

Mezzotinting is incapable of yielding really sharp edges or accents. It is therefore frequently pointed up by engraving or etching. In this early nineteenth-century example the artist etched the lines on his plate first and then rocked and scraped it. The final result in its natural size has somewhat the effect of a pen and wash drawing.

The most popular and rapid means of producing tints in the late eighteenth and early nineteenth centuries was by the etching process known as aquatint. In the usual eighteenth-century method rosin dissolved in spirits of wine was poured over a clean plate, which was then allowed to dry. In drying the rosin reticulated into little lumps leaving the plate bare between them. (Think of the way a mud flat dries into cakes in the sun.) The work then proceeded by an elaborate system of stopping out and biting (see page 46).

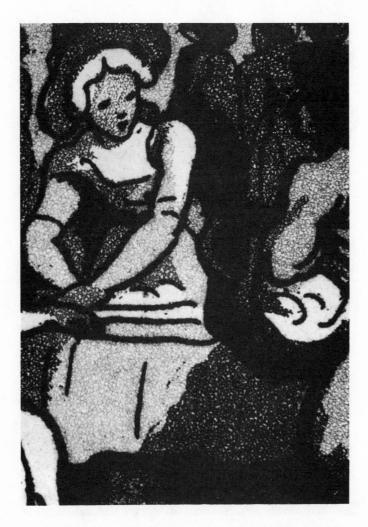

Aquatint, being incapable of sharp accents and thin lines, though only too capable of "hard edges," was frequently combined with line etching.

On rare occasion an aquatint ground was bitten heavily and evenly all over a plate, or a portion of it, and was then scraped and burnished just as though it were a mezzotint ground. Little original work was done in mezzotint or aquatint, though some that was done was artistically of great importance. Both were essentially indirect methods peculiarly suited for reproductive work.

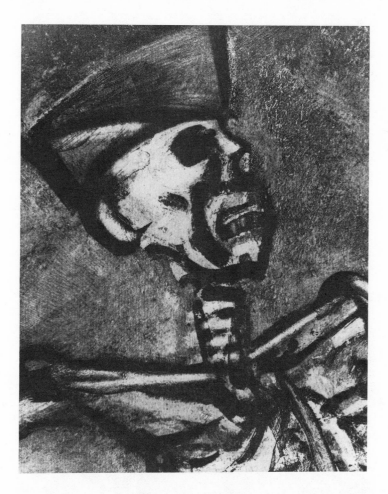

A painting can be reproduced photographically as an intaglio print by means of a photosensitive aquatint ground. One modern artist has made intaglio reproductive plates of his paintings which he then re-worked with etching, rocker lines, and aquatint. The combined optical effect of photographically reproduced paint impasto textures, as seen on the right in this detail, and the linear or granular effects of print techniques, as seen on the left, is exceptionally rich as well as somewhat disconcerting.

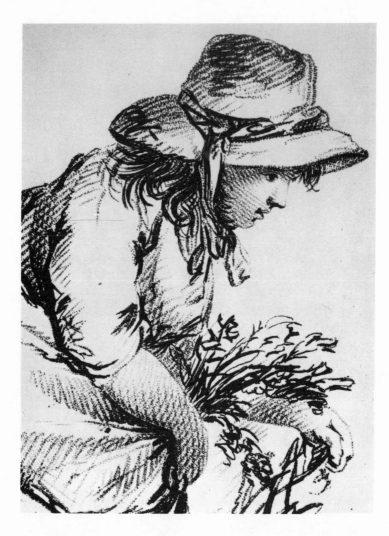

The engravers and etchers of the eighteenth century not only learned
how to make tones or tints but they learned how to make soft instead
of hard lines. The engravers made soft lines by using roulettes, i.e.,
tools with little wheels which had different sorts of spickers on their
outer edges. As different treads on tires make different patterns in the
dust so different roulettes made different marks on copper plates (see
the opposite page).

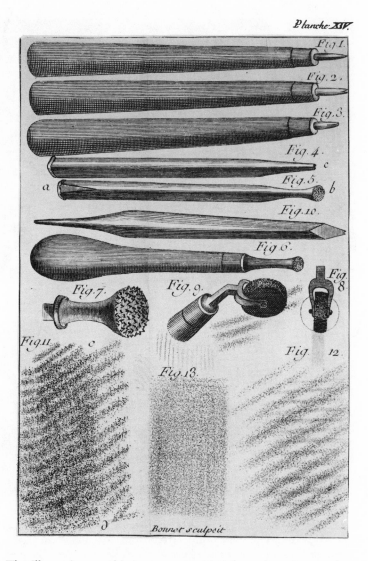

The illustration on this page represents eighteenth-century tools to make textured lines: a needle with one point (fig. 1), and others with several points (figs. 2, 3, 4) for use in stippling; a graver with two points (fig. 10) to make two lines at once; round-headed tools (figs. 5, 6, 7) and roulette wheels (figs. 8, 9) with patterns of jagged points on their heads and circumferences for use in crayon-manner engraving; and specimens of the textures produced by these tools (figs. 11, 12, 13).

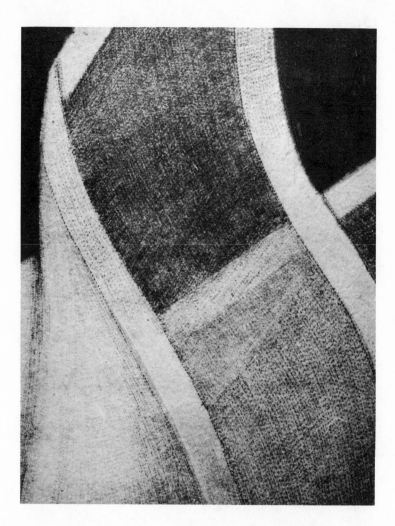

By running a rowel or spur over and over a plate its surface was covered with tiny pits and with corresponding spicules of metal that stood up from the surface in a burr like the pile of velvet. The lines followed by the spur in traveling over the plate can be easily seen in the accompanying reproduction. When the plate was inked and wiped the spicules held more or less ink depending upon their length, which in turn depended upon how much pressure was exerted upon the spur. The burr could be scraped or burnished down in places where it was too strong.

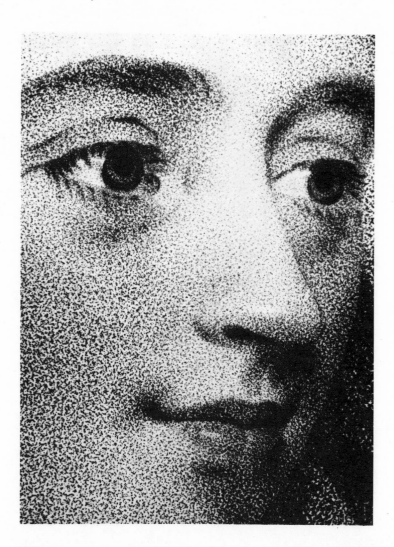

Stipple engraving was done by covering a plate with etching ground, making dots in the ground with a point, and then biting the plate with acid. It was a favorite eighteenth-century way of rapidly reproducing portraits and fancy heads in pencil and watercolor. It was often used in connection with roulette work (see pages 96 and 97).

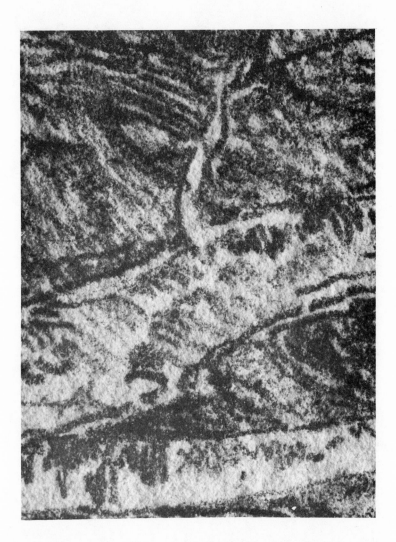

The etchers made soft lines by "soft ground" etching, They covered their plates with a mixture of ordinary etching ground and suet. Over this they stretched a piece of thin paper, on which they drew their picture with a pencil. This is a part of such a pencil drawing.

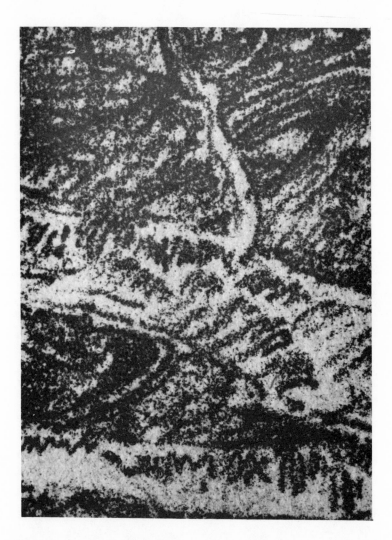

Wherever the pencil touched the paper it pressed it down into the soft ground so that in that place the ground stuck to the paper. When the paper was peeled from the plate it took with it the ground that stuck to it. The plate was then bitten with acid like an ordinary etching. This is the part of the etching that corresponds to the pencil drawing on the opposite page.

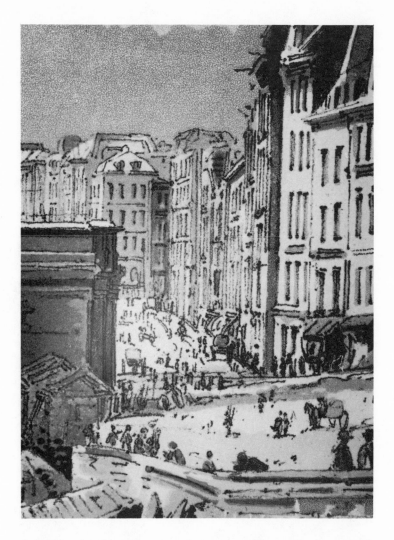

Soft ground and aquatint were frequently used together in imitation of pencil and wash drawings.

The Planographic Processes

LITHOGRAPHS

The principal planographic process, lithography, was invented just before 1800 by Alois Senefelder, a Bavarian.

The composition and texture of a lithographic printing surface is such that when water is poured or wiped over its clear surface, it will hold the water all over in a thin film. If the surface is greasy in any place, however, no water will remain there. When a roller charged with greasy ink is passed over such a moistened surface, the ink will leave the roller and adhere to the greasy spots but will not adhere to the wet areas. Up to a certain point the more grease there is on any spot the more ink will be left there by the roller.

There is an infinite number of ways of making the greasy marks—with a pen or brush loaded with thin grease in the

form of ink ("tusche") or with solid grease of different degrees of hardness put up in the form of crayons or pencils. The crayons and ink are made black so that their marks can be seen by the artist while he is making his drawing. Even the invisible, faint grease mark left on a stone by a sweaty finger will print. The grain of the surface, as it is finer or coarser, plays its part in the quality of the lines made upon it.

Traditionally, the lithographic printing surface has been a kind of fine-grained limestone; the best stones were quarried at Solnhofen (Franconia), Germany. Certain other materials share the peculiar qualities of the lithographic surface, however, and now that the Solnhofen quarries are virtually exhausted, specially processed zinc or aluminum plates are usually employed.

If a piece of paper, properly dampened, is laid upon the inked lithographic surface and rubbed down on it the ink will leave the surface and adhere to the paper, but the original grease marks will be left on the stone or metal plate so that the process of dampening the surface, inking, and printing on dampened paper can be repeated without having to make the greasy marks again.

Lithographs are printed in a press specially designed to rub the back of the paper as it lies on the inked stone or plate. The lithographic surface lies on a traveling bed that moves on rollers. After it is inked the dampened paper is laid upon it. On top of that a piece of thin, shiny cardboard is laid. The bed with its burden is then passed under a rounded edge that squeezes the cardboard and paper against the stone or plate.

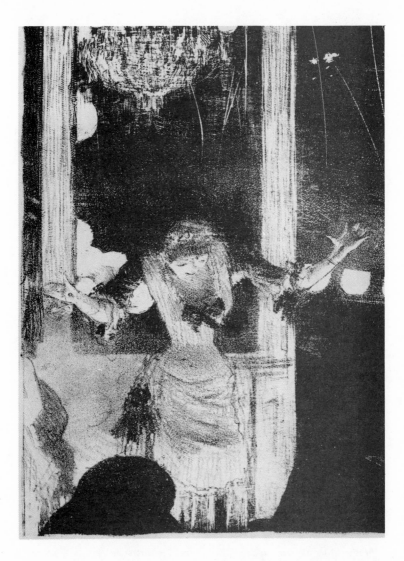

This is an approximately natural-size detail from a lithograph in which much work was done with a crayon and by scraping and scratching. Some of the smooches look as though they may have been made with the artist's forefinger or with a rag.

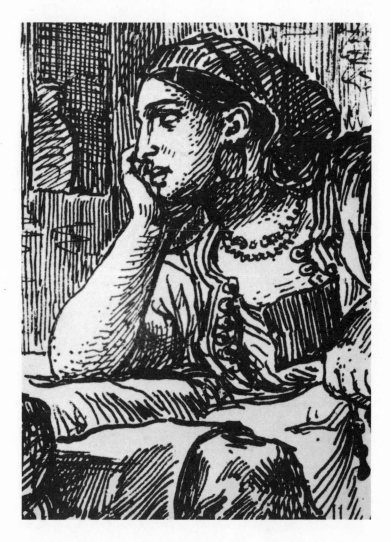

This is a detail from a pen lithograph. The artist made his drawing on the stone with a quill pen and a thin, greasy liquid ink.

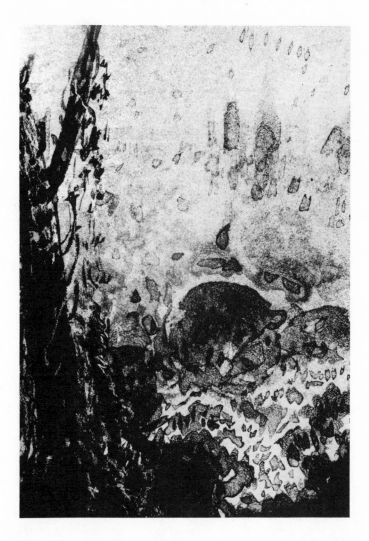

This is a detail from a wash lithograph. The artist worked on the stone with a watercolor brush and thin ink, just as though he were making a wash drawing on a piece of paper. The typical "hard edges" of watercolor are visible.

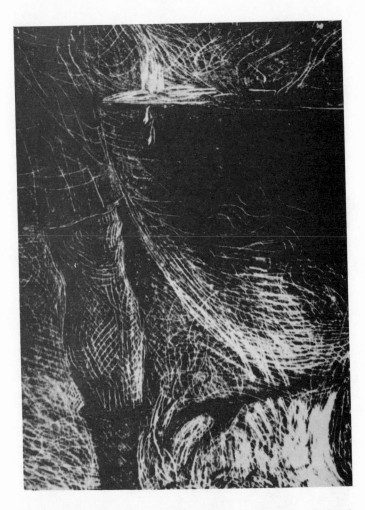

This is a detail from a scratch lithograph. The artist covered a dry stone with lithographic ink or thick heavy crayon and then scratched out his lights with a point. The white lines have the crumbly, broken character of scratches on polished stone—which is what they actually are.

A drawing made on paper with a lithographic crayon can be transferred to a lithographic surface by laying the drawing face down on a stone or metal plate and passing it through the press. While this can be done with almost any kind of paper, it is usually done with specially prepared "transfer paper." Thus it is possible for the artist to make his drawings anywhere that he can work on paper without having to carry the awkward stone or plate around with him or having laboriously to copy his drawings on paper onto a lithographic surface. Many of Whistler's lithographs were drawn on paper. The sitter for one of Whistler's lithographic portraits told the present writer that he redid his drawing almost forty times, working on transparent transfer papers laid down one on top of another so that he could use his last drawing as a tracing guide for his next one.

Naturally the texture of the transfer paper shows in transfer lithographs. Additional textures can be got by placing the transfer paper on a book cover, a textile, and so forth, while it is being drawn upon. Some painters, e.g., Fantin-Latour, have made their drawings for paintings on transfer paper and when one has proved especially attractive have had it transferred to a stone, worked it up, and then published it as a lithograph. It is not necessary that the artist who "makes a lithograph" should know anything about the technique of lithography, or even have seen either a stone or a press. The artist can make a drawing in lithographic crayon on paper and let the printer do the rest. Joseph Pennell, Whistler's friend and biographer, told the writer that Whistler was almost completely ignorant of the technique of lithography.

A fresh print from a stone or plate can be laid face down on another stone or plate and run through the press, thus transferring the design to the second printing surface. In this way it is possible to print editions of the same lithograph from two or more different stones or plates and so save time in production. Similarly, fresh prints from etched or engraved plates can be transferred and printed as lithographs. Sheet music used to be made this way.

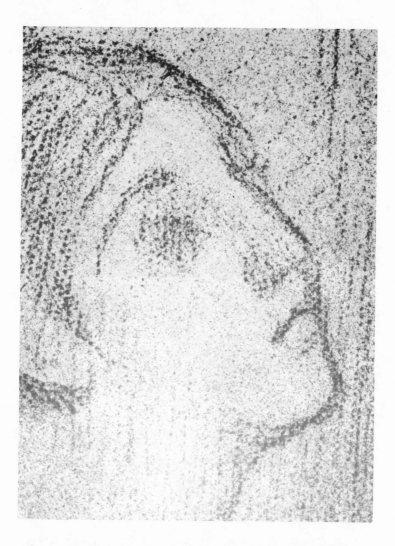

This is a detail from a transfer lithograph. The paper, while it was being drawn upon, was probably laid upon a pebbled cloth book cover or portfolio.

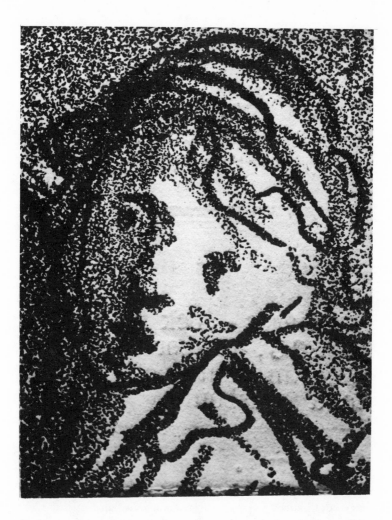

This is a detail from a newspaper caricature which started as a lithographic drawing on a stone. A print from the stone was transferred to a metal plate, which was then etched so that the whites were lower than the blacks. The plate was then printed, as though it were a woodcut, in the same press and at the same time as the text of the newspaper in which the caricature appeared. The impression of the lines into the paper can be seen in the reproduction.

Other planographic printing processes are based upon the principle of transparency, either to the passage of ink or of light, which acts as the printing agent. In the case of the stencil process, also known as "pochoir," a design is cut out of an impervious film. The stencil is laid upon the printing paper and brushed over with ink or paint. This method enforces a certain simplicity of design as no negative, or white, forms can be fully enclosed in a positive, or colored, area.

The silkscreen, or "seriograph," was developed to overcome the limitation in complexity of form inherent in the stencil. In the silkscreen, the blank areas are bridged by thin mesh which the printing ink can penetrate. The wet ink reforms on the paper as a continuous film. To make a silkscreen print, a mesh is stretched on a frame and, using a medium impervious to printing ink, the areas which are not to print are masked out. This may also be accomplished by dissolving or peeling away from the areas which are to print a preformed film that covers the entire mesh surface. Variations of these negative and positive design techniques can be accomplished with a photosensitized film. Once the design is formed as areas of clear mesh, ink is squeegeed across the entire surface, penetrating to the paper below. As a stiff ink is required so that it does not seep under the edges of the design, the color layer on the finished print is usually flat and opaque.

Photography can be considered a planographic printing process analogous to the stencil or silkscreen process. The photographic negative is transparent to light rather than to ink in the areas which are to print as positive images.

In the 1850s, shortly after the invention of photographic printing on paper by means of a negative of varying transparency, the "cliché verre" process of original printmaking was developed. In this technique a glass plate is either coated with ink completely, with the opaque coating then scratched away to form a design in transparent lines, or else it is worked with a viscous ink much like a monotype plate. The glass plate is then exposed to light as a negative to make a positive print on photographic paper.

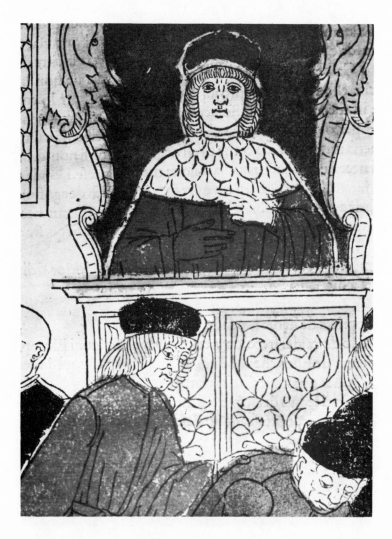

This is a portion of an Italian fifteenth-century woodcut book illustration colored with stencils.

In the twentieth century some extremely elaborate simulations of gouache painting have been executed in stencils. This is an enlarged detail of an original gouache design that served as a model for a stenciled book illustration.

This is an enlarged detail of a stenciled reproduction of a gouache painting much like that seen on the opposite page. It is executed in the same paints as the original design. Note how in the stencil the brush strokes cut across the outlines to form a raised bead of pigment, rather than follow and form the outlines as they do in the original gouache.

If the edges of a silkscreen design are examined under high magnification, the stepped contour of the filled area of the mesh can sometimes be seen. Also, the surface of the ink, if it was very viscous, sometimes retains the mesh pattern even after drying.

This *cliché verre* was made by scratching out the lines from an opaque film of dried ink or paint on a glass plate, which was then used as a negative to make a photographic print.

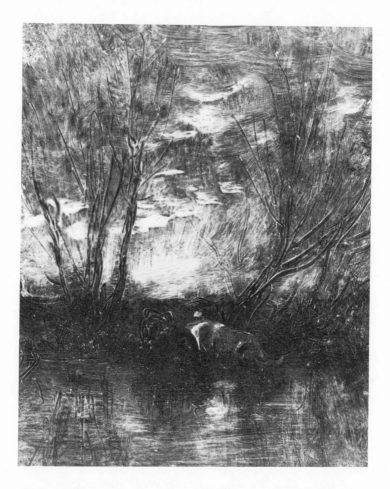

This *cliché verre* was made by wiping the design in a thick ink or paint onto a glass plate, which was used to make a photographic print.

Color in Prints

The earliest use of color in prints is found in the earliest prints. The earliest single-sheet woodcuts and book illustrations most frequently occur daubed up with strong colors applied freehand with a brush.

The earliest prints printed in color (i.e., other than black or brown) were engravings. These, however, were not true color prints as they were monochromatic, only one color, red, green, or blue, being used.

The earliest prints printed in color were woodcuts made by printing a line block and one or more flat color blocks on the same piece of paper. The line block was usually printed last. Pictorial woodcuts of this kind are generally referred to as chiaroscuros.

It was seemingly not until the late seventeenth century in Holland that anyone had the idea of inking an engraved or etched

plate in different colors, such as blue for the sky, green for the foliage, and red for the tile roofs, and so forth. Impressions of this kind are said to be printed "à la poupée," *poupée* being the French name for the roll of paper or cloth with which the colors are rubbed into the different lines on the plate. Prints made in this way are always somewhat blurry or smeared in the areas of color change, as it is not possible to make a sharp demarcation between any two colors. Plates in all the different techniques were printed *à la poupée*. In many instances the plates were printed in black or brown until they began to show wear, after which they were printed in color, thus rather effectively camouflaging the condition of the plate. In the eighteenth century engravers began to use a different plate for each color. Many prints printed in color received discreet retouching or accenting with watercolor. On rare occasions a combination of etched or engraved plates for the black lines and wood blocks for the color tints was used.

Probably more color prints were made in lithography than in any of the other techniques. A different stone was used for each color. Prints made in this way to simulate a polychromatic image were called chromolithographs or, more familiarly, "chromos."

The commonest of all old colored prints are those that were painted up in watercolor after being printed in black or brown. Prints in black or brown ink that have been colored by hand have black or brown lines and the color lies on the surface of the paper between them. Prints printed in colored inks have colored lines and the paper between the lines is apt to be white.

As most of the peculiarities of color prints cannot be brought out in black and white only a few are here illustrated.

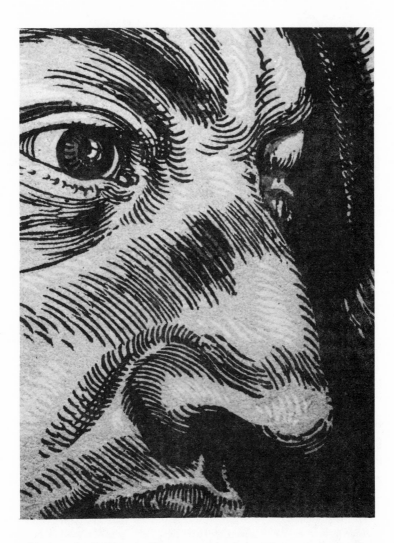

This is a detail from a chiaroscuro woodcut. There are three color blocks and a black block. The color blocks were an afterthought and were a means of covering up the distasteful damages that had been sustained by an older block for a black and white woodcut. Some of the black lines in the left eye have been broken, as can be seen in this enlargement.

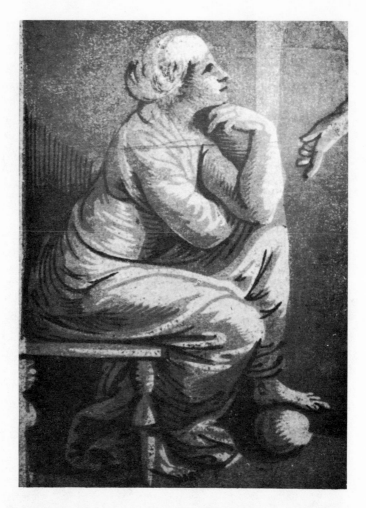

This is a detail from one of the most famous Italian sixteenth-century chiaroscuros. It can be seen that the black line here serves merely to provide a series of accents in the flat tones of the other blocks (see pages 119–20).

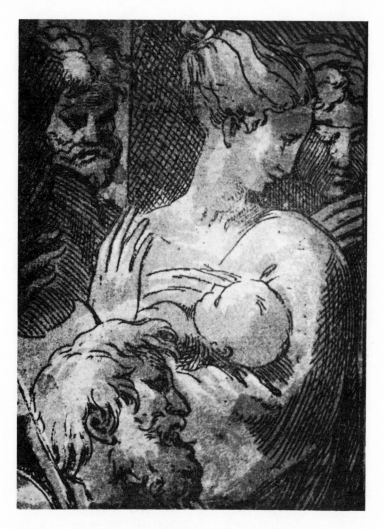

This is a detail from a technically simple sixteenth-century Italian combination of intaglio etching and relief tone blocks.

Of Copies, Facsimiles, and Other Bothersome Matters

There are imitations and copies in all media, but there are really no such things as true facsimiles in any medium. The "facsimile," even when meant to deceive, is practically certain to betray itself, if for no other reason than that in these days it is all but invariably made by another process than that used in making the original.

In the following enlarged reproductions it can be seen how the lines in the originals are very different from those in even the best copies and facsimiles. A somewhat subtler difference is that introduced when an impression of a late state is doctored to look like an earlier state. A little discreet attention with a bit of sandpaper or a knife will often remove lines or dots, but luckily this cannot be done without making the paper suspiciously thinner in all too apposite a place. Worn, weak lines are helped by retouch-

ing with a brush and india ink. This happens very frequently in the boundary line (the "trait carré") that runs around the outside of a great many renaissance woodcuts. But again, luckily, india ink when thick enough to resemble the full line of the woodcut has a color different from that of printer's ink and is apt to have a little shine of another kind when seen in a raking light. Worn lines in an etching or engraving can be replaced or strengthened with india ink and a very fine brush, but a brush line when enlarged does not really look like an etched or engraved line. Discreet retouching of a mezzotint with a brush and india ink is also not unknown. The crossing of two lines printed from a plate or a block in the same pull of the press is composed of but one layer of ink. If the two lines are separately printed, or if one of them is printed and the other is drawn, their crossing, when greatly magnified, clearly shows two layers of ink. The crossing of two drawn lines is composed of two layers of pigment.

The retoucher, and the copyist who makes another block or plate, is most apt to give himself away because he has not understood the shorthand of the original artist, and sometimes because he tries to make things "too good." It is hard for the retoucher or copyist to realize that very often the maker of the original was not as clever as he is or was not possessed of the same technical means. A familiar example is a late impression with telltale marks of its lateness that has had its face remade in a beauty parlor—like the wrinkles of age, little scratches that come only with lateness are incompatible with too full lines in other places. A copyist or forger photographs an original woodcut on a block of end wood instead of a block of side wood, and then, instead of cutting the block with a knife, engraves it with an engraving tool, and out of anxiety to make as perfect a reproduction as possible betrays the fact that he has used a tool that the maker of the original could not have used. In photomechanical reproductions the accidental accompaniments of the printing of the original—the blobbet of ink on the side of a woodcut line, the smear of ink on the surface of the drypoint plate—are caught up and made permanent and unvarying parts of the printing surface. The original wood block presses the ink on the top of the line into the paper, while the blobbet of wet ink on its side is not pressed into the paper

although it leaves its mark on it. In the reproduction both the top of the line and the blobbet on its side are pressed into the paper. The lines in a photogravure reproduction of an etching are shallow where the lines of the original plate are deep. The photogravure lines therefore do not stand up from the face of the print as do those of the original, and they cast none of the little shadows that are so important a part of the "quality of impression" of a fine original. It is a pity that most prints are only seen by artificial light because it is only possible to be keenly aware of these delicate qualitative things in raking daylight. In artificial light or top light they are extremely difficult to see. Because a photogravure is an etching it can never really have the character of an engraving, for the one is a shallow erosion and the other is a deep cutting.

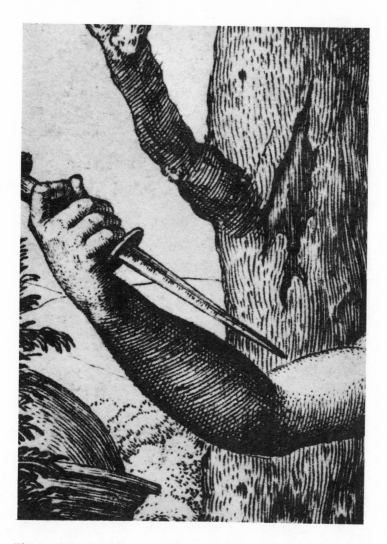

This is a detail from a fine early impression of Marcantonio's engraving *The Death of Dido*. On the following page is shown the same detail from a late impression from another plate of the same subject. Although Marcantonio's engraving has been frequently described, no mention appears to have been made of this other plate. Careful comparison reveals that while the outlines have the same measurements no two lines or dots are the same in the two prints.

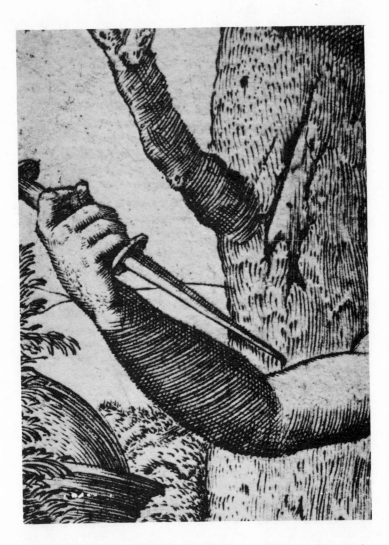

Comparison of this detail with that on the preceding page betrays the fact that the lines in this are not as well drawn as those in the other and that they lack indicative quality. The lines in the other are purposeful gestures; the lines in this are empty and without purpose. In their natural sizes these differences are not easily perceptible. Doubtless good early impressions from this plate masquerade as highly prized originals in many collections.

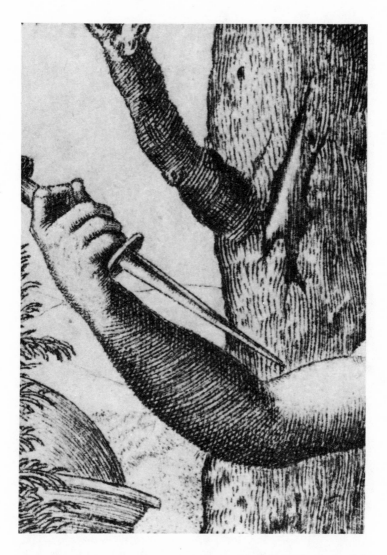

This detail is taken from an impression printed from Marcantonio's original plate after that plate, worn from use, had been reengraved to reinforce the lines. Thus a third version of the subject exists, which in "originality" lies somewhere in between the prints reproduced on the two preceding pages.

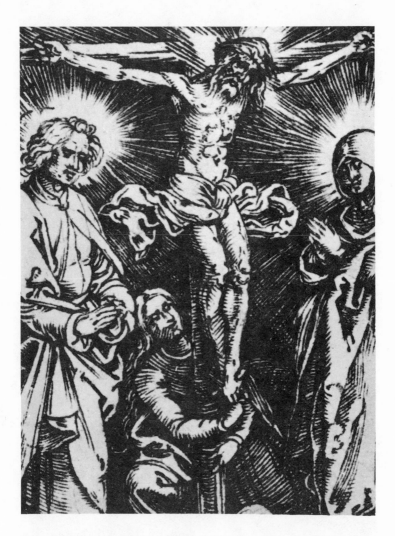

One of the most famous prints, as well as the smallest, made by Dürer was a little round Crucifixion engraved on a gold plate, which, after some impressions had been pulled from it, was mounted in the pommel of the Emperor's sword. It was not signed. There are three early versions and a number of later copies. For a long time opinion varied as to which of two of the early versions was the original. It is not easy to tell them apart with the naked eye.

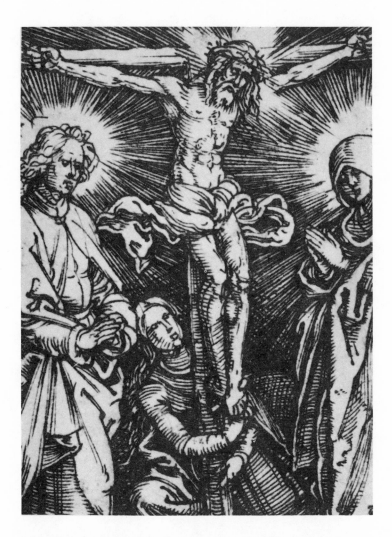

In the eighteenth and early nineteenth centuries this version was considered the original. More recently, however, most students have claimed that the version on the opposite page is the original. There is obviously a limit of smallness below which even the most skilled engraver cannot retain his fully autographic quality of line.

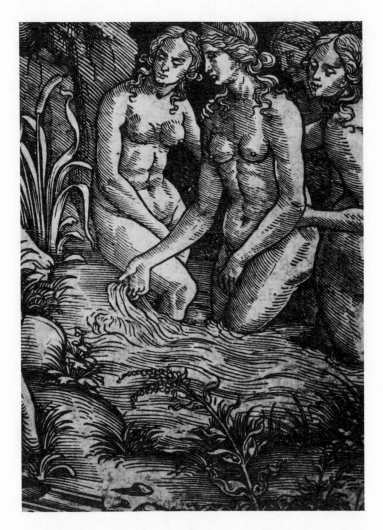

In general the most deceptive copies made before the days of photography were those of woodcuts. In the early sixteenth century copies were made of woodcuts by the Master I. B. with the Bird which were so close that they were only recognized a few years ago. When enlarged, however, the difference is patent. In this original the lines have intention and meaning. In the copy on the opposite page the lines have lost their intention. They have all the characteristics of careless

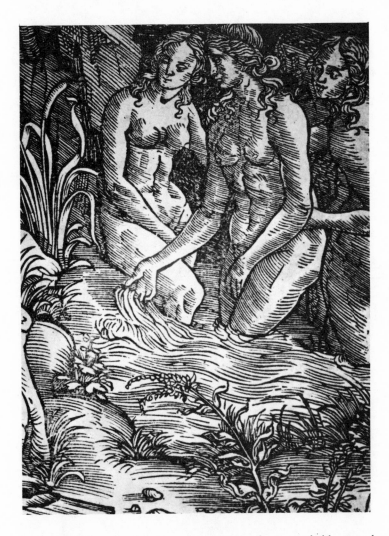

and unintelligent but laborious tracing: The forger probably pasted
an original impression face down on his block, rubbed it thin, treated
it with oil to make it transparent, and then cut his block through it—
a process that was sometimes used when the drawing for a woodcut
was made on paper instead of on the block. This forgery was repro-
duced by F. Lippmann as the original in his standard set of facsimiles,
The Woodcuts of the Master I. B. with the Bird (Berlin, 1894).

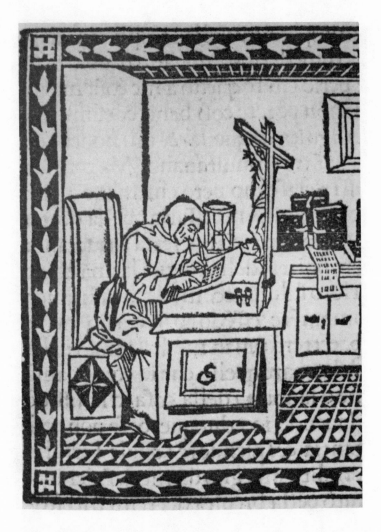

In the middle nineteenth century, before photography was in general use, Pilinski of Paris was famous (and notorious) for the deceptiveness of his copies of old woodcuts. This is an enlargement from an original fifteenth-century Florentine woodcut. On the opposite page is Pilinski's wood-engraved copy.

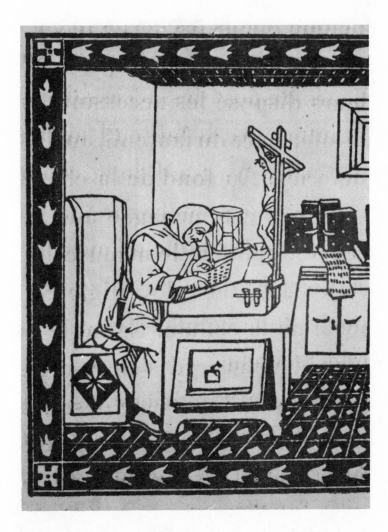

Pilinski had to redraw his copy of the old and valuable original because he could not paste the original on his block and engrave through it. Every line is different—every line is stupid—and the whole character has changed. In a number of places Pilinski completely misunderstood the "indications" of the original.

After photography had reached the point where drawings and old prints could be photographed onto wood blocks, the copyist and forger of old prints frequently called the camera to his aid as a means of getting an accurate picture of his original onto his block. This is a detail from an original woodcut by Dürer.

This is the same detail that is shown on the opposite page as it appears in a wood-engraved copy made over a photographic base. The copyist not only misunderstood the lines in the original but made the crucial mistake of introducing white lines and flicks of a kind that can only be made with a graving tool and not with a knife. This forgery is particularly interesting because it was illustrated as the original in Scherer's *Albrecht Dürer,* in the well-known series Klassiker der Kunst, in its 1904 edition, from which this reproduction had been made.

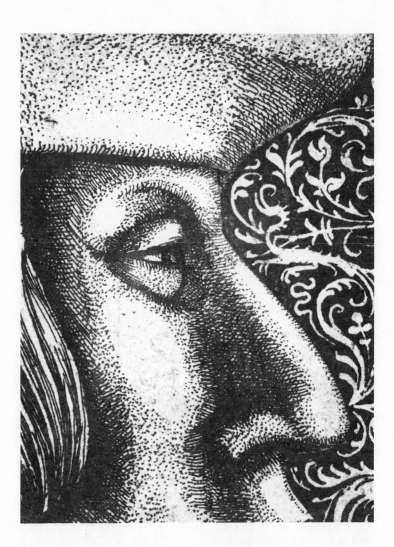

Facsimiles made before the day of photography were merely more or less careful handmade copies and actually had only a most superficial resemblance to their originals. The lines in most etchings are too fine to be traced off and have literally to be redrawn by the copyist. This is a detail from an etching on iron by the German sixteenth-century artist Jerome Hopfer.

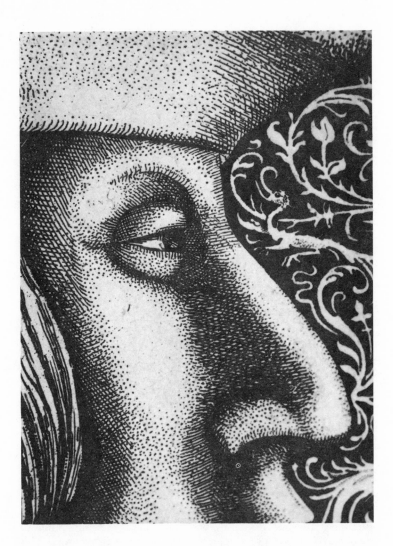

This is the best copy that an able etcher and copyist could make of the original on the opposite page. It was published at London in 1828 as a facsimile by W. Y. Ottley, the great collector and connoisseur of prints.

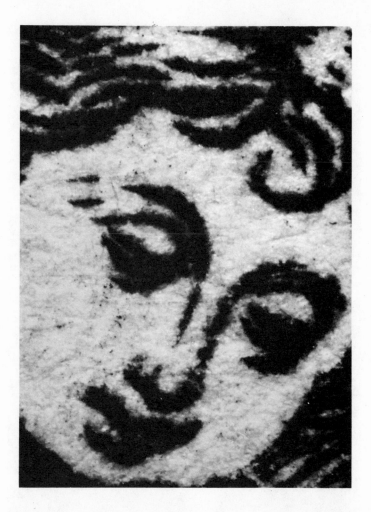

Facsimiles are made today by photomechanical methods. Some of these are deceptive at first sight, but enlargement tells the story. This is a great enlargement of a tiny head in the original of Schongauer's engraving *The Flight into Egypt*.

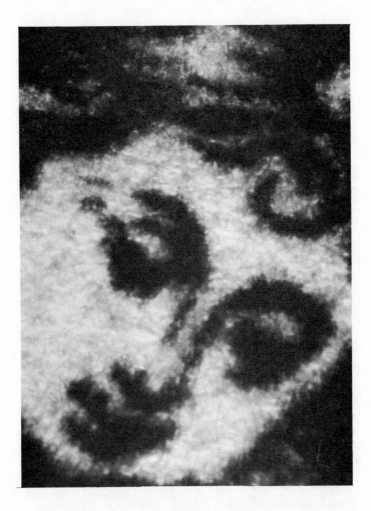

This is a reproduction of a most excellent and carefully made intaglio photomechanical facsimile of the head of the opposite page, which was made from the identical impression there reproduced. It is taken from Max Lehrs's standard set of facsimiles of Schongauer's engravings published by the Graphische Gesellschaft of Berlin in 1907. Note how coarse the fine tapering line defining the nose in the engraving has become in the facsimile.

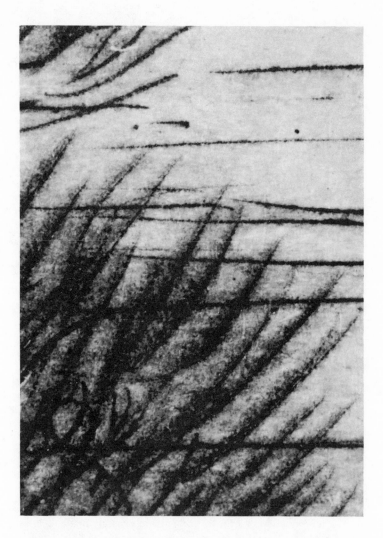

This is a detail from Legros's well-known drypoint *Le Canal*. The shaded ink is printed from the surface of the plate, from the film of ink caught by the burr of the drypoint lines.

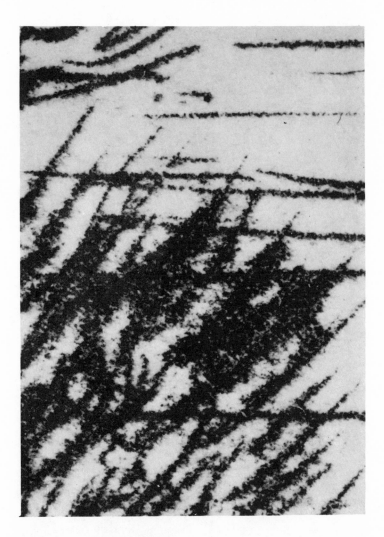

This is a process fake of the print on the opposite page—it was even signed with a forged pencil signature. What should be smooth unbroken surface ink shows the broken grain of the photogravure process by which the fake was made, and all of it lies below the surface of the clean-wiped plate. Photogravure is a refined combination of photography and aquatint. (See also pages 95 and 141.)

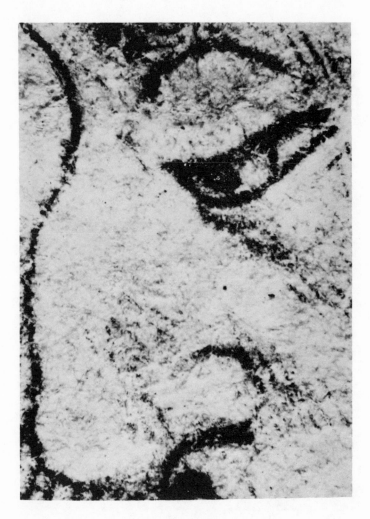

This is a detail from a fairly honest impression of a Dutch primitive engraving.

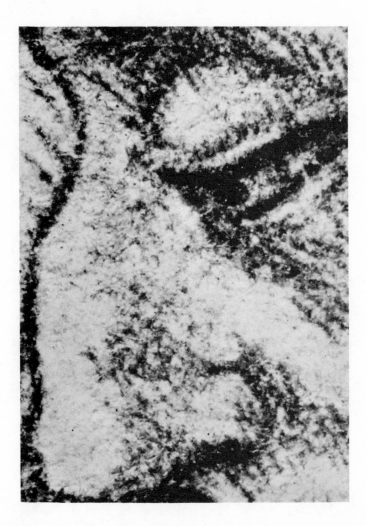

This is another impression of the same plate but one that "has had its face lifted" by a very able restorer, who has worked all over it with a brush in an ink somewhat paler than the ink of the printer.

In the early nineteenth century a faker made up an Italian primitive engraving out of whole cloth. It became famous as one of the finest early prints and so before long another faker made a fake of it which passed current as the "original." This enlargement of a small detail from the second fake shows it up as an Italian print of the Romantic period utterly devoid of all fifteenth-century character.

This enlargement shows how a restorer replaced a missing piece of a print by Mantegna with a different piece of paper on which he copied the missing engraved lines in pen and ink. This is a clumsy example chosen for its obviousness.

This is a portion of an impression from an etched plate. It is therefore in reverse of the work on the plate, i.e., what is the right hand on the plate is the left hand on the impression. A counterproof taken from an impression before its ink dries is in the same direction as the work on the plate. It is the reverse of a reversed printed image. The lines in a counterproof are flat like those in a lithograph.

This is a "touched" counterproof (i.e., one that has been drawn upon) of an early state of the print reproduced on the opposite page. The work on a plate is much more easily corrected or added to when the changes are worked out on a counterproof than on a direct impression, as they can then be carried over onto the plate without having to be reversed.

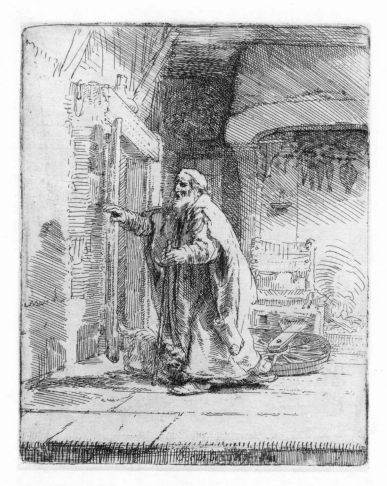

The eye habitually views an image from the lower left foreground, sweeping up and into the picture toward the right. This motion counters or reinforces spatial and dynamic effects inherent within the design. If an image is reversed, as it will be by virtually all printing processes, what is enhanced by the dynamics of vision will be diminished and vice versa. Some printmakers were more concerned with the visual effects of reversal than others, and in this respect Rembrandt seems to have been less premeditated in his compositions than most. This is the printed image of his *Blind Tobit*.

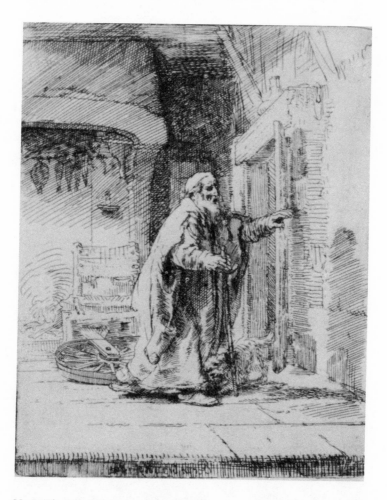

Here *The Blind Tobit* is seen reversed, as it would have been seen by Rembrandt as he worked on the plate. Only in this version is the gesture of the blind man, who misses his aim as he gropes toward the door, and the intention of his little dog, who attempts to block his collision with the wall, immediately intelligible. In the printed version reproduced on the opposite page the eye sweeps past these telling details to lose itself in the irrelevant void of the fireplace.

This is a detail from the margin of an etching by Meryon. After the printer had inked and wiped the plate but before he printed it, he wiped the ink out of the etched lines of the lettering on the margin. This made a late state look like an earlier state. The enlargement (in which the detail is reproduced sideways, with the inscription running from the lower left to the upper left) shows the "blind" (i.e., uninked) impression of the letters, which, standing up however microscopically from the surface of the paper, throw little shadows that can be read in a raking light.

Notes on a Few Points of Interest

On the Social Importance of the Graphic Techniques

A print may be defined as an image made by a process that is capable of producing a number of exact duplicates. Such an image cannot be made directly by hand, for no copy is like the original from which it is copied, and no copies are alike. This means that no two handmade pictures can tell the same things about the same object.

It can be reasonably argued that the great event of the fifteenth century was not the rediscovery of Greek or any other sort of ancient learning, but the discovery of mechanical ways to make pictorial records in duplicate, exactly, cheaply, and in vast quantities. This discovery made it possible for the first time to make pictorial statements and records in exact duplicate and to distrib-

ute them in invariant visual form simultaneously to many different people in many different places. The importance of this to human society can hardly be overstated. It has possibly had greater effects than any mechanical discovery since the invention of writing, as it is basic not only to our knowledge of the past and the present but to a very large number of our modern technological and scientific developments.

Since sometime in the 1400s men of the Western European civilizations have derived from duplicate pictures most of their knowledge of the shapes and textures not immediately at hand.

Only the very smallest proportion of these duplicate pictures was made for specifically artistic as distinct from informative reasons. So-called fine prints are only an infinitesimal and indefinable portion of the total number of printed pictures. Fashions in collecting and the blindness of students of "art" to all things not baptized as "art" have led to an almost complete misunderstanding and even ignorance of the actual functions and developments of the duplicate picture.

Each generation has had its particular and favorite form of duplicate picture. First there were woodcuts, then engravings, then etchings, after which there came in order across the centuries mezzotints, aquatints, wood engravings, and lithographs. In the 1830s came the beginnings of photography, out of which in turn came the photomechanical processes that produce halftones, line blocks, and all the other modern means of illustrating books, magazines, and newspapers. With the exception of lithography each of the prephotographic processes requires special techniques of draftsmanship that are based upon the nature of its peculiar tools and materials. Lithography, having no specially shaped drawing tool, uses those of ordinary men, crayon or pencil, pen, and brush. Whatever tools and materials are used, only certain very restricted kinds of statements can be made with any combination.

Seeing the world through its duplicate pictures, each generation has unwittingly read the qualities and defects of its duplicate pictures into its knowledge of the world, just as the man who wears green glasses sees the world all green. The last great change in the conditioning of human vision happened when people began to see in terms of photographs. The development of color photography and its reproduction in print-

er's ink has already begun to have its marked effect upon the public's sense of color. (Compare the following section on the influence of illustration and that on wood engraving on page 28.)

In view of all this the importance of being able to recognize the technique or process by which a printed or otherwise precisely duplicable image was made becomes obvious—for this knowledge enables us to discount or make allowances for the limitations, the blind spots, the distortions, implicitly and unknowingly introduced by techniques and processes into duplicate images and their testimony about the world. These implicit distortions are a most important part of the unconscious, unphrased, common assumptions of any human society, which basically determine its ideas and action. Very few people ever realize the extent to which "objective facts" as known by us are actually no more than peculiarities of our instruments of observation and record.

From a purely artistic point of view, however, the recognition of graphic techniques has little reward for anyone who is not himself a practicing graphic technician. The fact that a particular print is in one or another process has no more bearing upon its artistic merit than has the fact that it was printed in the basement or on the top floor.

The Influence of the Illustration

One of the most important factors in the development of the printed picture has been the steadily growing use of illustrations in printed books. Very few illustrations are made for the purpose of expressing the illustrator's personality or as works of art. The great majority of them have come into existence as conveyors of information or as tools in the struggles of opinion. A very small proportion were made as decorations to printed texts. In the long run the illustrator has made his pictures not to suit himself but to serve the ends of his employers and the needs, real or fancied, of the community, in the elucidation of a text. Since 1500 the form of printed picture that the community has been most familiar with has been the illustration in its familiar books. Although single-sheet prints of the special

kinds fancied by collectors of "fine prints" have almost always been executed in techniques or processes that were technologically obsolete, the greater number of single-sheet prints has at every time between the end of the fifteenth century and the end of the nineteenth century been executed in the techniques and linear styles that were for the moment most in use for illustration. The choice of the process and technique to be used in illustrating a book has, with few exceptions, always been dictated by a combination of economic and popular factors. Specifically artistic considerations have always played a subordinate role. Illustrations, like the books that contain them, have always been directed at particular social and intellectual groups, and the customs, pocketbooks, likes and dislikes of those groups have been taken into consideration as carefully as possible in the choice of the method of illustration. The printed picture, like the printed book, has in the main been directed at the middle class rather than at higher or lower classes and has conformed to its tastes and interests. The illustrated book has only flourished and been produced in large quantities in a bourgeois society. (The engraved-plate books of the eighteenth century are only an apparent exception, as their method of illustration made their costs so high and their editions so small that only the wealthy could have them.)

In general the principal function of illustration has been the conveyance of information. The graphic processes and techniques have grown and developed to the end of conveying information. The illustration that has contained the greatest amount of information, i.e., of detail, has been the one that was most in demand. As a result of this the graphic processes have shown an ever increasing fineness of texture. This increasing fineness of texture has repeatedly been carried to the point where the current process was no longer economically practicable, and then there has been a shift over to some other process that while producing approximately a similar result has been economically more advantageous. Thus the woodcut, which could be printed in one operation with the text, was for long the dominant mode of illustration. As time went on the texture of the woodcut got finer and finer until with the production of such cuts as those illustrated on pages 20 and 21 it became technically difficult, when not economically impossi-

ble, to print them in quantity on the papers and with the devices that were available.

The illustration on page 22 is dated 1557. After about that time the use of engravings and etchings as illustrations became more and more common, and the woodcut retained its place as typical illustration only in the volumes intended for the peddler's pack and the country fair, i.e., in books for naïve and poor audiences. By the end of the following century the texture of the copper plates in use for illustration had grown so fine that the plates could no longer yield big editions, and illustration became restricted to use in what may be called "de luxe" books. It is not without its interest to note that none of the picture books in which the pictures have become integral with the text in people's memories—e.g., the *Shepherd's Calendar*, the *Epistole e Evangelii*, the *Life of the Virgin*, *Slovenly Peter*, *Alice in Wonderland*—was illustrated with intaglio plates.

Just before 1800 Bewick in England and Senefelder in Germany invented wood engraving and lithography, both of which had textures almost comparable in fineness to those of the copper plate and were at the same time economically much more advantageous. For some years the presses and inking methods were not competent to cope with wood engravings of more than a few inches in area. The lithographic press, however, could turn out large prints. The wood engraving rapidly took its place within the texts of books, while the large full-page plates kept on being printed from copper plates and, on the continent of Europe, began to be printed from lithographic stones. As the nineteenth century wore on, improvements in the presses and inking methods gradually made it possible for wood engraving to be used in the making of full-page illustrations and eventually of the large double-page pictures in the popular weeklies. But here again the demand for fineness of detail was insistent and gradually led to a revolution not only in the techniques of the press but in the manufacture of paper. The development can be easily traced through the popular books and magazines. The illustrations in the *Century* of the early 1890s simply could not have been produced on the paper and in the presses that produced *Harper's* during the Civil War.

By the beginning of this century the photomechanical relief

processes had come into general use and the older handmade printing surfaces rapidly lapsed from use except for very special purposes. Having thus lost their general economic justification and stabilization most of the old techniques became languages used for their own sweet sakes rather than for their power and utility. They left the work and the sweat of life and took their places at the vicar's tea table, where their accents and manners were of more account than what they thought and said.

The Important Techniques

It may in general be assumed that the greater an artist the simpler his prints are from a strictly technical view. This does not mean that the technique was not used expertly, nor that it is necessarily easy to diagnose. "Wood engravings" on end wood have been made with etching needles and even with sharp fragments of broken glass (A. B. Davies). Tints have been laid on etchings by scratching the grounded plates with sandpaper (Camille Pissarro). While wholly unorthodox, these methods are extremely simple. The more complex and artificial the technique of a print, especially in the way its lines are laid, the more certain one may be that its maker was a craftsman translator and not a creative artist. The price of virtuosity is abject slavery to a complaisant tool, that of creative artistry is willful dominance over a recalcitrant tool. The world has a curious but encouraging habit of forgetting the virtuosi. The only two techniques that really are of artistic importance are rarely or never mentioned in essays and books on the graphic techniques. They are those of pictorial imagination and sharp-sighted, sensitive draftsmanship. No one can ever be taught these two great techniques, for they are part of the eternal mystery of personality and its growth, to be recognized but not to be rationalized or reduced to a method. They can no more be imitated than wit.

Of Reproductive Prints

Until about one-hundred years ago most of the printed pictures that were made and collected were reproductions of paintings

and drawings. In the late 1830s Fox Talbot, using paper negatives, made the first photographs. In the 1850s negatives on glass became practical. In 1879 George Eastman took out patents for the first machine to coat sheets of glass with a sensitive photographic emulsion. His patents for the first photographic films were taken out in 1884. The first halftone in a periodical has been said to be one that appeared in the New York *Daily Graphic* on March 4, 1880. The basic patent for the modern "crossline halftone screen" was issued in 1886. Today photography and photomechanical processes have taken the place of the classical handmade graphic techniques. Most of the changeover took place between 1880 and 1905. This has had great effect upon print making, both economically and artistically.

Of Reproductive Print Makers

The reproductive print makers, and they were at least ninety-nine percent of all print makers, were craftsmen copyists, or, as they preferred to be known, "translators," a euphemism that gave them much comfort. As the imagination, composition, and draftsmanship were given to them in the paintings and drawings they copied, all they had to think about was their manual skill. Because the pictures reproduced were taken for granted, the questions to be asked about a print were not whether it was a good picture or drawing but whether from a technical point of view it was a good etching, engraving, and so forth, and whether from a comparative point of view it was a "fine impression." Today, thanks to photography, prints stand on their own feet as works of art and any need for knowledge or opinion about them as exercises in particular techniques has long since been submerged under the infinitely more important problems of their composition, imagination, and draftsmanship. The answers to these problems require no knowledge of the reproductive techniques, and, no matter what the answers may be, they render any question whether a print is a "good etching" or a "good engraving" both pedantic and superfluous. Less than forty years ago Goya's prints were regarded as "bad etchings" and the masterly prints made by Daumier in the 1860s as "bad lithographs."

In 1653 Abraham Bosse wrote, "Pour celuy qui desire d'estre Graveur . . . tout le principal fonds qu'il doit faire est du dessein; car ensuite la Gravure, soit au burin ou à l'eau forte, ne luy sera qu'un jouet pour l'execution." A century and a half later William Blake summed the matter up when he wrote, "Painting is drawing on canvas, and engraving is drawing on copper, and nothing else, and he who pretends to be either painter or engraver without drawing is an imposter."

On the Economics of Print Publishing

It would seem that the first professional print publishers made their appearance in the first half of the sixteenth century. Publishers have rarely made their own prints and have usually hired other men to make them for them. They have not wanted prints by particular men so much as they have wanted prints of particular kinds representing particular kinds of subject matter. It is as economically easy as it is artistically regrettable to see why the print trade has always liked regular dependable producers of standardized goods, and has not favored contemporary print makers who have had adventurous developments and whose subject matters and techniques have showed much change or variety.

The growth of print publishing as a trade and a manufacture resulted in a separation into different professions of the practice of picture making and the practice of the graphic techniques, so that at the Ecole des Beaux Arts in Paris the painters and draftsmen took one course and the print makers another. As in all similar situations this brought about not only a rather high average level of technical skill among the professional print makers but also rather a dead level of impersonal, undifferentiated skill. Engraving and etching became mechanical crafts. In the event the engraver all too often became a mere hand on an assembly line. From this shop practice developed the artificial linear structures and textures that for several hundred years were the outstanding characteristics of the commercial printed pictures that were made in such quantity. It has always been commercially desirable that engravings should be quickly made, for the engraver's time costs money and it is wasteful to tie up capital in idle plates. It was only possible to produce

a series of engravings quickly by dividing the work among a number of different engravers. To preserve homogeneity in a series of engravings it was necessary that the engraving in all should be as nearly the same as possible. It was also desirable that several men should be able to work on the same plate according to their particular specialities. Therefore the engravers were taught and disciplined in conventional, artificial, linear systems. This reached perhaps its highest development of impersonality in the production of large white-line wood engravings for the weekly magazines, which were made on big blocks that came apart into little pieces, each of which was engraved by a different man. When put together again it was requisite that there should be as little difference as possible between the work on the several bits of wood in the big block. In time the engravers took pride in these goose steps and in elaborating them. The conventional linear systems became widespread—it is only the copybook hand that is easily imitated—and skill in them was looked upon as a test of an engraver's ability. It is very important, however, to remember that these lock-step linear systems were inherent, not in the technical processes with which they became associated in the popular mind, but in the economic setup of the highly organized manufacturing business that print making had become.

The so-called facsimile woodcut, in which the cutter's or engraver's task was to remove the wood from between the lines drawn by the artist on the block, was the only classical form of print manufacture which retained any of the original artist's lines. It is because of this that the illustrations in the woodcut books of the past are so frequently aesthetically superior to those in the copperplate books of the past. The illustrations in the old copperplate books, unless, as very rarely happened, they were engraved by the original designers, were merely copies, few good and many bad, of original designs in other media. This same thing was true of the wood engravings in white-line tints that were popular as illustrations in the second half of the nineteenth century. Lithography has a somewhat similar story. Although many great painters and draftsmen have made original drawings on lithographic stones, not only as isolated works of art but as book illustrations, posters, political caricatures, and so forth, the overwhelming number of lithographs has consisted of mere routine copies in laborious

techniques of designs conceived and first carried out in other media.

Of the Maintenance of Standards

On occasion one hears people remark that "artistic standards" should be "maintained." Less frequently one hears it said that "standards of quality" should be "maintained." Both remarks are based on a fallacy in reasoning that comes from an ambiguity in the meaning of the word standard. In manufacture and trade a standard is something that other things should and can exactly resemble. Standard dollars are interchangeable—it makes no difference which dollars one has, so long as one has a given number of them. The same thing is true of the standardized parts of an automobile and of standard quart cans of tomatoes of any particular brand. The great standard works of art, however, are the works of art that no other work of art is like. So far from being happy and satisfied when it is discovered that two works of art are just alike, people promptly become worried and unhappy over the situation. Experts are called in, lawsuits are started, and there is trouble until it is finally decided that they are not just alike and that one of them is a fake. The only standards that can be maintained are the very opposite of "artistic," because they are the standards of impersonalized routine production. If they were to be maintained in art, art would die. It is worthwhile to think how few of the reproductive and professional print makers of the past are remembered. They have been forgotten precisely because they standardized their quality and then maintained their standards. The man, like the society, that does this has stopped thinking and experiencing and become a mere machinery of frozen habit. Every new tool or material, every new process, and every change in religious or social theory and habit introduces change that is incompatible with "maintenance of standards."

Of Quality of Impression

"Quality," unfortunately, has nothing to do with the major artistic virtues such as imagination, composition, or drafts-

manship, but is a matter solely of the printer's skill and the condition of his printing surface. Whether or not a particular impression is a good or a fine impression is a matter to be decided only by direct comparison with other impressions of the same print or by memory of such other impressions. Only a very small number of people have dependable memories of this kind of thing, and no one has an infallible memory. If other impressions are not available then one has to take what he can get—and if anyone likes what he can get, it is a good impression for him. What is fine quality for one print has no bearing on what is fine quality for another by another artist. Any good artist has a quality of his own that is just as idiosyncratic as his drawing. When two artists have very nearly the same quality one or the other (and probably each!) is of very little artistic importance.

It is important to remember that as yet no one seems to know how the early engravers and etchers printed their plates, in what kind of a press, or under what pressure. The early impressions of early engravings, especially the large Italian ones, are often very irregularly printed, as though the plates had been very carelessly wiped after being inked in soft ink or oil paint that was carelessly rubbed into the lines, and as though the pressure in printing had not been the same all over the plate. While some lines have a lot of ink in them, others have little or none. The early impressions not infrequently seem to have slipped in passing through the press or its equivalent, so that some of the lines are smeared or doubled. There is reason to believe that the hard, even, late impressions of many of the early plates were printed long after the plates were made and by a press or other device of a kind not used in printing the early soft impressions.

There is rarely any need for having a modern print in poor condition. Fifteenth-century prints in fine condition are apt to be also rather late and poor impressions. Really fine early impressions of them are apt to be in rather poor condition. Almost the rarest things in the world are very old prints that are fine in both quality and condition.

Too great an emphasis on condition or quality of impression is apt to wind up by turning prints into precious stones or postage stamps instead of the drawings and pictures they actually are and removes them into some category quite other

than that of works of imaginative art. It is said that according to modern fashionable standards many of the prints that Dürer proudly gave to his great friend and patron the king of Denmark are mediocre impressions. A print that is worth having only in a very fine impression is doubtfully worth having in any impression whatever. The poorest impression of a really great print, no matter how shabby it is, is still a great work of art.

It is useful to remember that print makers, print collectors, and print users of the past never dreamed of us of today or of our tastes and prejudices in regard to quality and condition. The feeling that prints should not be colored, like the feeling that they are precious things to be kept in mats and handled as little as possible, is comparatively modern. Most of the very great old collections were pasted rather carelessly in scrap-books, and big prints were kept loose in portfolios or drawers. Just as most primitive woodcuts were daubed up with crude color, so early Italian engravings and etchings were frequently either colored or heightened in effect by more or less discreet use of pen or brush. For a long time prints were regarded simply as pictures of which there were many duplicates (much as photographs are today), and not as things of a special kind with special values and special rituals. They were bought by artists and craftsmen for use and were part of the customary working equipment of the studio or shop. On occasion they were pricked all over or squared off as the easiest way of taking off their designs for use.

Of States and Watermarks

The beginner should make most careful differentiation between state, condition, and quality. They are quite different and in many instances are independent variables. Every change in the work on a printing surface as shown by comparison of the prints pulled from it indicates a change in state. These changes are sometimes made by the artist in furtherance of his pictorial idea, sometimes they amount to no more than a change in the punctuation of the name or the address of the publisher or dealer, sometimes they are made by any skilled hand that is available to cover up or disguise the wear that is inevitably

undergone by the printing surface in the course of its use. Mere wear, by itself, however, even though it results in the complete disappearance of lines and the altering of values, does not make a difference in state. Condition has no relationship to either state or quality, but is a matter solely of the physical condition of the piece of paper on which the print was printed. Prints frequently occur that are late in state and horrid in quality but in superb condition.

At the very beginning of his study of prints the student is faced by one of the basic problems in that branch of philosophy known as epistemology. Most of the vast accumulation of learning about states, watermarks, and so forth arises from the understandable but fruitless attempt to find describable marks such that knowledge of them through second-hand verbal description will take the place of first-hand sensuous recognition of quality of impression. For many print collectors these marks play the role played by the wine label for the man who tells whether a wine is good or bad by reading in a book and not by tasting in a glass. It is important always to remember that the condition, state, or watermark of a print carries no guaranty of its being a good impression, let alone a fine one. Most of the talk about quality of impression goes back not to first-hand judgment but to memory of verbal representations made in view of sale, which should be recognized as such. It is worth noting how few statements about quality are to be found on receipted bills.

Of the Examination of Prints

The full quality of a print can only be observed in a raking white light, preferably daylight, such as falls from an ordinary window on a table. The person examining a print should hold it so that in looking at it he faces across the light and not into it. This is the way in which the texture of the paper and the highlights and shadows on the face of a print make their strongest effect.

The lines in an intaglio print stand up above the surrounding surface, which itself is slightly concave in the narrow spaces between lines. As light plays across an intaglio print the concave

surfaces between the lines catch the light in microscopic high-lights on the sides away from the source of light and have microscopic shadows on the sides toward the source of light. The shadows can be seen in the reproduction of a blind impression on page 152, and the highlights can be seen in the left arm in the reproduction on page 67.

The lines in a relief print are sunk into the paper, so that they lie below the surrounding surface, which itself is slightly convex in the spaces between the lines. As the light plays across a relief print the convex surfaces between the lines catch the light in microscopic highlights on the sides toward the source of light and have microscopic shadows on the sides away from the source of light (see the reproduction on page 111).

Not only are the subtle three-dimensional characteristics of printing methods, which are a large part of the attraction of the original print, enhanced by raking light; the specific fibrous and textural character of the paper is also thereby revealed. It is the intimate and distinctive interplay of paper and ink that distinguishes each print as a unique object of particular quality from another.

Viewing a print in strong raking daylight is also the best way to detect repaired damage, for no matter how skillfully the restorer has matched the tone of an old paper, or its weight, or the lines on it, he will probably have been unable to duplicate its exact texture. Even the insertion of a patch of matching old paper, whose structure appears identical when the print is viewed by transmitted light, i.e., with the light shining through it, will probably be detectable or at least suspected in a strong raking light. The reverse of a print should also always be inspected, and evidence of damage seen on the back should be carefully compared to the corresponding areas on the front.

A print that has been too much washed or cleaned and especially one that has been subjected to strong pressure while damp is apt to have lost the relief of its lines and spaces and with it the shadows and highlights above described. For this reason many connoisseurs prefer old prints that are somewhat dirty or that have slight stains, but that still retain their full relief and texture, to others that have been cleaned and pressed.

At one time it was customary among framers to paste prints down flat on pasteboard or to paste them down around their

edges while damp so that in drying they would become taut and flat. These methods were even used by dealers in fine prints. Each method is one of the worst enemies of fine prints, though the latter is not so disastrous in its results as the former, which has utterly ruined countless numbers of wonderful things.

Of Enlargements

An appreciation of the effects both of the materials and techniques of prints and of their aging and restoration can only be gained by much looking and comparison, with the naked eye under good illumination and also with a magnifying glass. One should become accustomed to looking at the best examples of all techniques under magnification, for the appearance of a print thus viewed is often different from that seen with the naked eye. Then, when a "problem" print requires examination with a glass, it will be easy to distinguish the normal appearance of a technique or condition under magnification from the abnormal.

It is frequently said that certain kinds of prints do not enlarge well in reproduction or lose their interest when enlarged. The illustrations in this book prove, on the contrary, that all kinds of prints enlarge well. What does not enlarge well is not any particular kind of print but the work of particular (and all too many) artists. The work of any artist who has a marked sense of form or texture enlarges well. If an artist has little sense of form or texture his work enlarges badly. Form and texture are not merely local or superficial matters but dominate the whole composition and get down into the minutest detail, and an artist who has an innate sense of them on any scale has it on all scales. A print that seems to fall apart when enlarged was never really together. Enlargement merely makes artistic poverty more obvious. It is also obvious, of course, that any print can be fully appreciated for its aesthetic values only when seen in a good original in its original size, i.e., without either enlargement or diminution. Changes in scale of the kind brought about by enlargement, although essential for technical examination, introduce changes in our physiological ocular awareness of values and brilliances, and distort our psychological reactions in many subtle ways.

On the facing page there are two diagrams: one composed of black squares separated by white lines, the other composed of two squares made up of parallel lines. The squares in the second are exactly alike except that in one the lines are perpendicular and in the other they are horizontal.

If any one of the crossings of the white lines in the first diagram is looked at for a moment it will appear white but the other crossings will have flickering gray cores. If a crossing is looked at intently for a few seconds it also will have a flickering gray core.

Any person who has an astigmatism—and perfect eyesight is exceedingly rare—will see the lines in one of the two squares in the second diagram as being darker than those in the other. If the book is turned so that the horizontal lines become perpendiculars and the perpendiculars become horizontals, the darker square will become the lighter one.

These two experiments in the way the human eye works help to explain some of the specific qualities peculiar to many prints in black and white. Incidentally they point to the reason that reproductions, either in black and white or in full color, are necessarily untruthful in their values and hues unless they are of the same size as the originals from which they are made, even though they may be printed in identically the same pigments. Before one is through with the questions raised by these diagrams he has to wrestle not only with problems in the physiology and mechanism of vision but with a number of the basic problems in philosophy, more especially in the field of epistemology. To anyone interested in knowing how he knows what he sees and the extent to which he can and should trust his eyes these diagrams provide the starting point for fascinating and most important experiment and thought.

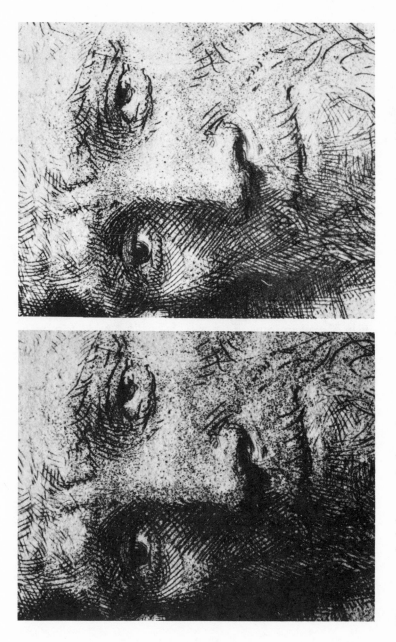

Two unretouched photographs from the same unretouched negative. Never trust a photograph of a print too much.

Bibliography

This bibliography is in general limited to recent publications in English, or recent reissues of older books, for which the latest edition is cited. Its orientation is toward conceptual and technical readings, in consonance with the subject of this book. Innumerable publications organized by artist, school, chronology, or nationality are also available, of course, and some of these also contain excellent technical observations.

Many of the following books are redundant, but more than one on any given subject are listed so that the reader will be able to locate at least one.

GENERAL

Eichenberg, Fritz. *The Art of the Print*. New York: Harry N. Abrams, 1976. Profusely illustrated historical survey with notes on technique by contemporary printmakers.

Hayter, Stanley William. *About Prints*. London: Oxford University Press, 1962. Complex and subtle technical discussions with comment also on print marketing and collecting, oriented toward modern prints.

Ivins, William M., Jr. *Prints and Books*. New York: Da Capo Press, 1969. Essays on traditional artists' prints, reproductive prints, and illustrated books.

————. *Prints and Visual Communication*. New York: Da Capo Press, 1969. Intellectual and conceptual history of the development of printmaking through the nineteenth century, with a bias against the most recent developments.

Jussim, Estelle. *Visual Communication and the Graphic Arts: Photographic Technologies in the Nineteenth Century*. New York: R. R. Bowker, 1974. The author takes up the tale where Ivins withdrew in his *Prints and Visual Communication*.

Mayor, A. Hyatt. *Prints and People*. New York: Metropolitan Museum of Art, 1971. Brilliant successor to the conceptions of Ivins, with much idiosyncratic historical detail.

Riggs, Timothy A. *The Print Council Index to Oeuvre-Catalogues of Prints by European and American Artists*. Millwood: Kraus International Publications, 1983. Invaluable bibliographic guide, alphabetical by artist.

Zigrosser, Carl, and Christa M. Gaehde. *A Guide to the Collecting and Care of Original Prints*. New York: Crown Publishers, 1975. An old-fashioned guide with sound advice on the care of prints.

TECHNICAL

General

Boston Museum of Fine Arts. *Exhibition Illustrating the Technical Methods of the Reproductive Arts from the Fifteenth Century to the Present Time, with Special Reference to the Photo-mechanical Processes*. Boston: A. Mudge & Son, 1892. A mine of in-

formation about nineteenth-century reproductive processes written by Sylvester Rosa Koehler, Ivins's only worthy predecessor; not illustrated.

Brunner, Felix. *A Handbook of Graphic Reproduction Processes*. Teufen: Arthur Niggli, 1962. Trilingual, somewhat dogmatic explanations of original and reproductive print techniques, profusely illustrated.

Eppink, Norman R. *One Hundred and One Prints*. Norman: University of Oklahoma Press, 1971. Simple technical descriptions of every conceivable printing process including photography, illustrated entirely by the author, thus introducing the dubious value of stylistic consistency into the examples.

Gascoigne, Bamber. *How to Identify Prints*. New York and London: Thames and Hudson, 1986. The most thorough, articulate, and ingeniously organized book on print identification, covering both original and photoreproductive techniques. Fully illustrated and lavishly produced.

Gilmour, Pat. *The Mechanized Image: An Historical Perspective on Twentieth-Century Prints*. London: Arts Council of Great Britain, 1978. Technical analysis of the modern transformation of printmaking.

———. *Understanding Prints: A Contemporary Guide*. London: Waddington Galleries, 1979. An excellent exposition of traditional and contemporary techniques, all presented in a modern context.

Goldman, Judith. *American Prints: Process and Proof*. New York: Whitney Museum of American Art, 1982. What begins as a chronological history of American printmaking develops into a study of the evolution of individual contemporary prints through states.

Griffiths, Antony. *Prints and Printmaking*. London: British Museum Publications, 1980. Brief, intelligent, and readable survey with emphasis on visual recognition of techniques.

Newton, Charles. *Photography in Printmaking*. London: Victoria and Albert Museum, 1979. Brief introduction to the contribution of photographic techniques to original printmaking.

Peterdi, Gabor. *Printmaking: Methods Old and New*. New York: Macmillan, 1959. Exceptionally clear, profusely illustrated technical explanations of intaglio and relief processes.

RELIEF

Hatton, Warwick. *Making Woodcuts.* New York: St. Martin's Press, 1973. Brief and well illustrated.

Hind, Arthur M. *An Introduction to a History of Woodcut.* 2 vols. New York: Dover, 1963. This and the volume by Hind listed below under "Intaglio" are standard and still serviceable surveys but with limited reproductions; their emphasis is on the early centuries.

Jackson, John, and W. A. Chatto. *A Treatise on Wood Engraving.* 2d ed. London: Henry G. Born, 1861. Lengthly historical and technical work discussing woodcut and wood engraving.

Rumpel, Heinrich. *Woodengraving.* New York: Van Nostrand Reinhold, 1972. Actually discusses woodcut.

Sander, David M. *Wood Engraving.* New York: The Viking Press, 1978. Brief, expert, and profusely illustrated.

INTAGLIO

Dyson, Anthony. *Pictures to Print: The Nineteenth-Century Engraving Trade.* London: Farrand Press, 1984. The commercial history of a now unpopular intaglio art form; it includes a detailed technical section.

Hind, Arthur M. *A History of Engraving and Etching.* New York: Dover Publications, 1963.

Lalanne, Maxime. *A Treatise on Etching.* London: Sampson, Low, Marston, Searle, & Rivington, 1880. Practical treatise on traditional techniques, with original intaglio illustrations.

Lumsden, E. S. *The Art of Etching.* Philadelphia: J. B. Lippincott, 1925. Thorough discussion of traditional techniques with an especially good section on printing papers.

Short, Sir Frank. *Etchings and Engravings: What They Are, and Are Not, with Some Notes on the Care of Prints.* London: Royal Society of Painter-Etchers and Engravers, 1912. Exquisitely printed, with original intaglio impressions and also photographically enlarged illustrations of technique.

PLANOGRAPHIC

Antreasian, Garo Z., and Clinton Adams. *The Tamarind Book of Lithography: Art and Techniques.* New York: Harry N.

Abrams, 1971. Detailed techniques are presented, art only by implication.

Cate, Phillip Dennis, and Sinclair Hamilton Hitchings. *The Color Revolution: Color Lithography in France, 1890–1900*. Rutgers, N.J.: Rutgers University Art Gallery, 1978. Modern essays with a reprint of seminal 1898 essay by Mellerio.

Glassman, Elizabeth, and Marilyn F. Symmes. *Cliché-verre: Hand-Drawn, Light-Printed*. Detroit: The Detroit Institute of Arts, 1980. Historical survey and contemporary sampling of work in this photographic technique.

Metropolitan Museum of Art. *The Painterly Print: Monotypes from the Seventeenth to the Twentieth Century*. New York: Metropolitan Museum of Art, 1980. Multiple and occasionally redundant essays on unique prints.

Porzio, Domenico, et al. *Lithography: Two Hundred Years of Art, History, and Technique*. New York: Harry N. Abrams, 1983. Well-illustrated survey which reprints Senefelder's account, "The Discovery of the Lithographic Stone."

Paper

Hunter, Dard. *Papermaking: The History and Technique of an Ancient Craft*. New York: Dover Publication, 1978. Standard history of oriental and occidental papermaking.

Robison, Andrew. *Paper in Prints*. Washington, D.C.: National Gallery of Art, 1977. Subtle but idiosyncratic analysis of the relationship between paper and fine art prints; not illustrated.

Webb, Sheila. *Paper: The Continuous Thread*. Cleveland: The Cleveland Museum of Art, 1982. Discussion of paper relative to fine art prints; illustrated.

List of Illustrations

Unless otherwise noted, originals of the prints reproduced are in the Print Room of the Metropolitan Museum of Art.

Portion, slightly reduced, of the original block of Dürer's woodcut *Samson and the Lion* (Bartsch 2). 10

Detail, slightly reduced, from an early impression of Dürer's woodcut *Samson and the Lion* (Bartsch 2). 11

Detail from the second edition of Turrecremata's *Meditationes,* printed at Rome in 1473 (Hain-Copinger 15724). The same block was used in the first edition (Rome, 1467), which is generally regarded as the first book printed from type and illustrated with woodcuts made in Italy. 12

Enlarged detail from a woodcut in the *Aesop* printed at Verona in 1479 (Hain-Copinger 345). 13

Enlarged detail from a white-line woodcut, from Pelbartus's *Pomerium de sanctis* (Augsburg, 1502). 14

Enlarged detail from a woodcut in Frezzi's *Quatriregio* (Florence, 1508 [Kristeller 164]). 15

Enlarged detail from a woodcut by Christoffel van Sichem in Hugo's *Pia desideria emblematis* (Antwerp, 1628). 16

Detail from J. Bell's woodcut after one of Hogarth's *Four Stages of Cruelty*. 17

Enlarged detail from the woodcut by Titian and Domenico dalle Greche entitled *Pharaoh's Army Submerged in the Red Sea* (Rosand and Muraro 4). 18

A slightly reduced reproduction of Altdorfer's woodcut *Saint Jerome, in a Cave* (Bartsch 57). 19

A: An early "proof" impression (before 1538) of the woodcut *The Duchess* from Holbein's *Dance of Death*. The initials HL in the lower left corner are those of the cutter, Hans Lutzelburger. *B:* An impression of the same block as printed in Langlois, *Essai sur les danses des morts* (Rouen, 1852). *C:* The wood-engraved copy of *A* made by John Byfield and printed in Douce's *Dance of Death* (London, 1833). As usual, the easiest place to detect the difference between original and copy is in the lettering, i.e., in the monogram HL. *D:* An early "proof" impression (before 1538) of the woodcut *The Countess* from Holbein's *Dance of Death*. All reproductions are slightly smaller than the originals. 20

Much enlarged detail from *The Countess* in Holbein's *Dance of Death*. 21

Enlarged detail from a woodcut dated 1557 in Ostaus's *Vera perfettione del disegno* (Venice, 1567). 22

Enlarged detail from the metal cut ("schrotblatt") *Saint Martin* (Schreiber 2703). 24

Enlarged detail from a metal cut of the *Adoration of the Shepherds* in Pigouchet's *Book of Hours* (Paris, 22 August 1498 [Hain-Copinger 8855]). 25

Enlarged detail from an impression of one of Blake's relief etchings for his *Songs of Innocence,* as reprinted from the original copper plate in Gilchrist's *Life of William Blake* (London, 1863). In the reprint the rough margins were not covered by a "frisket" and in consequence can be clearly seen. 26

Slightly enlarged detail from Daumier's *Empoignez-les Tous, Ma Chère* (Bouvy 32). 27

A nineteenth-century wood engraver's hands at work. From Jackson and Chatto, *A Treatise on Wood Engraving,* second edition (London, 1861). 29

Enlarged detail from the wood engraving of the solitary snipe made by Thomas Bewick for his *British Birds* (Newcastle, 1797–1804). 30

Enlarged detail from a wood-engraved headpiece, engraved by Luke Clennell after Thomas Stothad, for Roger's *Pleasures of Memory* (London, 1810). It is reproduced from a copy of the book printed on China paper. 31

Enlarged detail from Harvey's wood engraving after B. R. Haydon's painting *The Death of Dentatus.* The story of this remarkable tour de force of engraving and the difficulties attending its printing can be found in Johnson's *Typographia* (London, 1824, vol. 2, pp. 538 and 547). 32

Enlarged detail from Birouste's facsimile wood engraving after Daumier, *Grande Ménagerie Parisienne* (Bouvy 333), which appeared on the yellow paper wrapper of Huart's *Muséum Parisien* (Paris, 1841). The figure blowing the trumpet is a caricature by Daumier of himself. 33

Enlargement from a "proof" impression of Blake's original wood engraving for Virgil's "First Eclogue" in Thorton's *Pastorals of Virgil* (London, 1821). 34

Enlarged detail from Thomas Bolton's wood engraving after Flaxman's *Deliver Us from Evil*. Reproduced from Jackson and Chatto's *Treatise on Wood Engraving,* second edition (London, 1861). It is one of the earliest instances in which the engraver photographed his subject onto his block instead of redrawing it. 35

Enlarged detail from a wash drawing on a block by Mary Halleck Foote. 36

Enlarged detail from the wood engraving of the wash drawing reproduced in the preceding illustration. 37

Enlarged detail from Henry Wolf's wood engraving after Vermeer of Delft's painting *Young Woman at a Window*. 38

Enlarged detail from a photograph of Vermeer of Delft's painting *Young Woman at a Window*. 39

Enlarged detail from Timothy Cole's wood engraving after Constable's painting *The Haywain*. 40

Enlarged detail from an intaglio impression (i.e., one printed as though it were an etching) from the electrotype of the wood block of Timothy Cole's wood engraving after Constable's painting *The Haywain*. 41

Enlarged detail from W. J. Linton's wood engraving portrait of Allen Wardell. 42

Enlarged detail from R. A. Dobois's three-color linoleum cut *Le Béguinage de Bruges* (collection of the Harvard University Art Museums). 43

Seventeenth-century burins, or gravers. From Bosse's *Traicté des manières de graver en taille douce . . . par le moyen des eaux fortes, & des vernis durs & mols* (Paris, 1645). 49

Seventeenth-century burins, or gravers. From Bosse, *Traicté des manières*. 50

A seventeenth-century etching or engraving press. From Bosse, *Traicté des manières*. 51

Enlarged detail from Rembrandt's etching and drypoint *Abraham's Sacrifice* of 1655 (Bartsch 35 [collection of the Harvard University Art Museums]). 52

Much enlarged detail from Rembrandt's drypoint *The Three Crosses* (Bartsch 78). 53

Much enlarged detail from Rembrandt's mixed etching and drypoint portrait of Jan Six (Bartsch 285). 54

Very greatly enlarged detail from the lower left corner of an exceptionally early impression of Dürer's engraving *The Promenade* (Bartsch 94). 55

Enlarged detail from a very early impression of the engraved *Head of an Ecclesiastic (three quarters to the right)* by a member of "the school of Leonardo" (Bartsch XIII, 241, 21). 56

Enlarged detail from a very late impression of the print reproduced in the preceding illustration. 57

Enlargement of the head of Saint Andrew from an exceptionally early impression of Mantegna's engraving *The Risen Christ between Saint Andrew and Saint Longinus* (Bartsch 6). 58

Very greatly enlarged detail of the head reproduced in the preceding illustration. 59

Much enlarged detail from an exceptionally early impression of Schongauer's engraving *Christ before Pilate* (Bartsch 14). 60

Enlarged detail from a photograph of Vermeer of Delft's painting *Young Woman at a Window*. 39

Enlarged detail from Timothy Cole's wood engraving after Constable's painting *The Haywain*. 40

Enlarged detail from an intaglio impression (i.e., one printed as though it were an etching) from the electrotype of the wood block of Timothy Cole's wood engraving after Constable's painting *The Haywain*. 41

Enlarged detail from W. J. Linton's wood engraving portrait of Allen Wardell. 42

Enlarged detail from R. A. Dobois's three-color linoleum cut *Le Béguinage de Bruges* (collection of the Harvard University Art Museums). 43

Seventeenth-century burins, or gravers. From Bosse's *Traicté des manières de graver en taille douce . . . par le moyen des eaux fortes, & des vernis durs & mols* (Paris, 1645). 49

Seventeenth-century burins, or gravers. From Bosse, *Traicté des manières.* 50

A seventeenth-century etching or engraving press. From Bosse, *Traicté des manières.* 51

Enlarged detail from Rembrandt's etching and drypoint *Abraham's Sacrifice* of 1655 (Bartsch 35 [collection of the Harvard University Art Museums]). 52

Much enlarged detail from Rembrandt's drypoint *The Three Crosses* (Bartsch 78). 53

Much enlarged detail from Rembrandt's mixed etching and drypoint portrait of Jan Six (Bartsch 285). 54

Very greatly enlarged detail from the lower left corner of an exceptionally early impression of Dürer's engraving *The Promenade* (Bartsch 94). 55

Enlarged detail from a very early impression of the engraved *Head of an Ecclesiastic (three quarters to the right)* by a member of "the school of Leonardo" (Bartsch XIII, 241, 21). 56

Enlarged detail from a very late impression of the print reproduced in the preceding illustration. 57

Enlargement of the head of Saint Andrew from an exceptionally early impression of Mantegna's engraving *The Risen Christ between Saint Andrew and Saint Longinus* (Bartsch 6). 58

Very greatly enlarged detail of the head reproduced in the preceding illustration. 59

Much enlarged detail from an exceptionally early impression of Schongauer's engraving *Christ before Pilate* (Bartsch 14). 60

Enlarged detail from a "maculature" impression of Marcantonio's engraving *A Woman Watering a Plant* (Bartsch 383). 61

between the first and second states of the catalogs. Right, the second state described in the catalogs. 76

Much enlarged detail from an "engraving" by Woollett after George Smith of Chichester (Fagan 44). 77

Much enlarged detail from J. S. Helman's "engraving" after 32au le jeune's drawing for *Les Délices de la Maternité* (Bocher 1354) in the "Monument du Costume." This is reproduced from the etched state before the plate was finished by engraving. 78

Much enlarged reproduction of the same detail in its final engraved state. 79

Enlarged detail from Rembrandt's mixed etching and drypoint *The Agony in the Garden* (Bartsch 75). 80

Enlarged detail from Dürer's etching *The Sudarium Held by One Angel* (Bartsch 26). 81

Enlarged detail from Rembrandt's etching *A Nude Woman (seated on a bench beside a hat)* (Bartsch 199). 82

Enlarged detail from Marcantonio's engraving *The Judgment of Paris* (Bartsch 245). 83

Enlarged detail from Guilio Campagnola's engraving *Saint John the Baptist* (Bartsch 3). 84

Enlarged detail from Daniel Hopfer's *Two Panels of Ornament* (Bartsch 90). 85

Much enlarged detail from Rembrandt's etched *Portrait of Jan Cornelis Sylvius* (Bartsch 280). 86

Enlarged detail from Jan Lutma's the Younger's dotted-manner *Portrait of P. C. Hooft* (Wurzbach 4). 87

Enlarged detail from one of Everdingen's etchings illustrating *Reynard the Fox* (Bartsch 16). In a private collection. 88

Eighteenth-century mezzotint rockers, a knife, and a burnisher. From Bosse's *De la Manière de graver à l'eauforte et au burin* (Paris, 1758). 89

Enlarged detail from the uncleaned margin of a trial proof of a mezzotint by David Lucas. 90

Much enlarged detail from one of the prints in Turner's *Liber Studiorum.* 91

Much enlarged detail from Delacroix's aquatint *The Smith* (Delteil 19). 92

Enlarged detail from Rowlandson and Alken's etching and aquatint *Cuckfield,* from Wigstead and Rowlandson's *Excursion to Brighthelmstone* (London, 1790). 93

Much enlarged detail from Goya's scraped aquatint *The Giant* (Delteil 35). 94

Detail from Rouault's reworked photogravure of his painting *Debout les Morts,* plate 54 from *Miserere et Guerre* (Collection of the Harvard University Art Museums). 95

Enlarged detail from a roulette engraving after a drawing by Morland. 96

Eighteenth-century points and roulettes. From Bosse, *De la Manière de graver.* 97

Enlarged detail from Ludwig von Siegen's *Portrait of the Landgravine Amelia Elizabeth* (Delaborde 1). Although frequently referred to as the first mezzotint, this print is not really a mezzotint, as that term can be applied only to a print from a rocked plate. 98

Enlarged detail from Collyer's stipple engraving of Miss Farren after Downman. 99

Enlarged detail from the original pencil drawing of John Crome's soft-ground etching *Study of Three Trees* (Theobald 31). 100

Enlarged detail from John Crome's soft-ground etching *Study of Three Trees.* 101

Enlarged detail from Girtin's soft-ground and aquatint *View of the City with the Louvre, etc., taken from Pont Marie.* 102

Detail, actual size, from Degas's lithograph *Aux Ambassadeurs— Mlle Becat* (Delteil 49). 105

Enlarged detail from Delacroix's pen lithograph *Femmes d'Alger* (Delteil 97). 106

Much enlarged detail from J. D. Harding's brush and wash lithograph *Le Casset, Vallée du Monetier*. 107

Enlarged detail from Delacroix's lithograph *Macbeth Consulting the Witches* (Delteil 40). 108

Enlarged detail from Puvis de Chavanne's lithograph *La Toilette*. 110

Enlarged detail from Daumier's "lithograph" *La République Nous Appelle* (Delteil 3810). 111

Detail from *The Anatomy Lesson* in Ketham's *Fasciculus Medicinae* (Venice, 1493 [Hain-Copinger 3449]). 113

Enlarged detail from Severini's gouache *L'amour compose le tableau* (collection of the Harvard University Art Museums). 114

Enlarged detail from Severini's pochoir illustration for *Fleurs et masques* of 1930 (collection of the Harvard University Art Museums). 115

Greatly enlarged detail from Lichtenstein's silkscreen *Brushstroke* (Waldman 14 [collection of the Harvard University Art Museums]). 116

Detail from Daubigny's *cliché verre Bouquet d'aunes* (Delteil 145 [collection of the Harvard University Art Museums]). 117

Detail from Daubigny's *cliché verre Vaches à l'abreuvoir* (Delteil 146 [collection of the Harvard University Art Museums]). 118

Enlarged detail from a seventeenth-century chiaroscuro impression of Dürer's woodcut *Portrait of Ulrich Varnbüler* (Bartsch 155). 121

Enlarged detail from Ugo da Carpi's smaller chiaroscuro *Raphael and His Mistress* (Bartsch XII, 140, 2). 122

Enlarged detail from Parmigiano's etching and chiaroscuro *Saint Peter and Saint John Healing the Sick* (Bartsch 7). 123

Enlarged detail from Marcantonio's engraving *The Death of Dido* (Bartsch 187 [private collection]). 127

Enlarged detail from an undescribed early forgery of Marcantonio's *Death of Dido*. 128

Enlarged detail from a later, retouched impression of Marcantonio's *Death of Dido*. 129

Much enlarged detail from Dürer's round engraving *Christ on the Cross* (Bartsch 23 A). This was engraved on a round piece of gold, 40 mm in diameter, used to decorate the pommel of the emperor Maximillian's sword. Bartsch thought this a copy. 130

Much enlarged detail from an early forgery of Dürer's round *Christ on the Cross* (Bartsch 23). Bartsch thought this the original. 131

Enlarged detail from the Master I. B. with the Bird's woodcut *Diana and Actaeon* (Bartsch 2). 132

Enlarged detail from an early forgery of the Master I. B. with the Bird's woodcut *Diana and Actaeon,* which was reproduced as the original by Lippmann in *The Woodcuts of the Master I. B. with the Bird* (Berlin, 1894). 133

Enlarged detail from the woodcut *Savonarola in His Cell* from Savonarola's *Libro della semplicità della vita christiana* (Florence, 1496 [Kristeller 392 b]). 134

Enlarged detail from Pilinski's copy of the same, from Gruyer's *Illustrations des écrits de Jérome Savonarole* (Paris, 1879). 135

Enlarged detail from Dürer's woodcut *The Assumption of Saint Mary Magdalen* (Bartsch 121). 136

Enlarged detail from wood-engraved copy of Dürer's *Assumption of Saint Mary Magdalen,* reproduced as the original in the Klassiker der Kunst volume on Dürer (Leipzig, 1904, p. 181). 137

Enlarged detail from Jerome Hopfer's etched *Portrait of the Emperor Charles V* (Bartsch 58). 138

Enlarged detail from a copy of Hopfer's *Portrait of Charles V,* in Ottley's *Facsimiles of Scarce . . . Prints of the Early Masters* (London, 1828). 139

Greatly enlarged detail from Schongauer's engraving *The Flight into Egypt* (Bartsch 7). 140

Greatly enlarged detail from the facsimile of Schongauer's *Flight into Egypt* in Lehrs, *Martin Schongauer, Nachbildungen seiner Kupferstiche* (Berlin, 1914). 141

Enlarged detail from Legros's drypoint *The Canal*. 142

Enlarged detail from a process reproduction (fake) of Legros's *Canal*. 143

Enlarged detail of an impression of the Master of Zwolle's engraving *The Adoration of the Kings* (Bartsch 1). 144

Enlarged detail of another impression of the same plate showing the "improvement" of its tonal range by the addition of washes. 145

Greatly enlarged detail from an early nineteenth-century fake niello engraving *The Adoration of the Kings* (Duchesne 32). 146

Detail from a damaged impression of Mantegna's engraving *The (Oblong) Entombment* (Bartsch 3). 147

Enlarged detail from Rubens's etching *Saint Catherine* (Dutuit VI, 131, 15, 2d state). 148

Enlarged from touched counterproof of the first state of Rubens's *Saint Catherine*. 149

Reduced reproduction of Rembrandt's *The Blind Tobit* (Bartsch 42 [collection of the Harvard University Art Museums]). 150

The reproduction on the preceding page here printed in reverse, so that the composition is seen in the same form as it was by Rembrandt when he worked on the plate. 151

Enlarged detail from the uninked margin of an impression of Meryon's etching *La Pompe Notre Dame* (Delteil 31). 152

Two diagrams of optical illusions. 168

Two untouched photographs printed from the same negative after Rembrandt's *Jan Cornelis Sylvius* (see p. 86). 170